Growing Season

The Life of a Migrant Community

Photographs by Gary Harwood Text by David Hassler

Foreword by Robert Coles

The Kent State University Press Kent, Ohio

This publication was made possible in part through the generous support of

Aultman Health Foundation

The Family of Heather and Jeffrey Fisher

Key Foundation

Ohio Arts Council

The publisher will contribute a portion of the proceeds from sales to the Hartville Migrant Center.

Library of Congress Catalog Card Number 2006003578
Cloth ISBN-10: 0-87338-873-9 ISBN-13: 978-0-87338-873-3
Paper ISBN-10: 0-87338-892-5 ISBN-13: 978-0-87338-892-4
Printed in China

10 09 08 07 06 5 4 3 2 1

Portions of this book appeared previously in *Double Take/Points of Entry Magazine,* Spring 2006. Photos on pages ii, 23, 34, 81, and 101 appear courtesy of Kent State University.

The views expressed in *Growing Season* are not necessarily those of its supporters and publisher.

LIBRARY OF CONGRESS CATALOGING-IN-PUBLICATION DATA
Harwood, Gary, 1959–
Growing season the life of a migrant community / photographs by Gary Harwood ; text by David Hassler ; foreword by Robert Coles.
p. cm.
ISBN-13: 978-0-87338-873-3 (alk. paper) ∞
ISBN-10: 0-87338-873-9 (alk. paper) ∞
1. Migrant labor—Ohio—Hartville—Pictorial works.
2. Agricultural laborers—Ohio—Hartville—Family relationships—Pictorial works.
I. Hassler, David, 1964– II. Title.
HD1527.02H37 2006
305.9'630977162—dc22 2006003578

British Library Cataloging-in-Publication data are available.

Growing Season

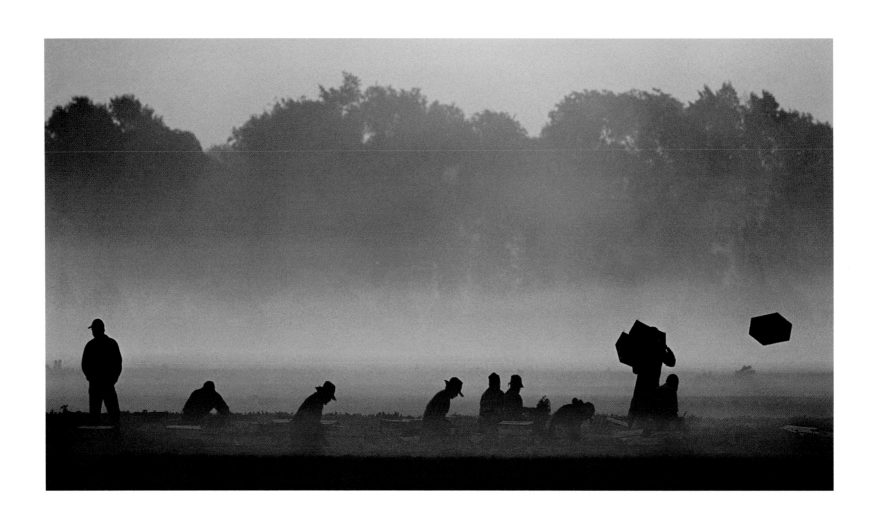

For Carole
and my parents, Frank and Sylvia Harwood
G. H.

For Lynn and Ella
D. H.

With gratitude to all the families of *Growing Season*
for their generosity and trust
G. H. & D. H.

Contents

Foreword

During the 1960s my wife, Jane, and I got to know African American families in the southern United States, some of whom worked in what public health officials called the "Eastern stream" of migrant farm workers: individuals who harvested crops in Florida during the winter and spring and then moved north to work during the summer and fall. At that time migrant farm workers, who were primarily African American or of Caribbean descent, were unprotected by the labor laws that made life easier for other Americans. They were outside the political as well as the economic mainstream of America.

In getting to know those workers, we learned how much more we needed to understand about them—it being all too easy to regard them as hard-pressed, even exploited. Many were. But just as many were sturdy and vigorously able to take care of themselves and their loved ones; as a matter of fact, I began to learn that these men and women were shrewd observers of those who observed them and had much to teach us. I remember in particular a husband and wife who were beautifully attuned to one another in the field—how they picked the crops, set them aside, and moved on to the next acre of challenge. Tired of merely observing, one day Jane and I got down on our hands and knees and began picking the crops we had been watching others pick. The migrants taught us how to cut vegetables, pick them, leave them together, and shield them from the weather. I realized I was learning this new skill the same way I had learned to perform surgery as a young medical student: control my hands, follow certain routines, summon painstakingly whatever skills I could find in myself.

As I read the words and looked at the photographs that make up this extraordinarily knowing and telling book, my mind went back to these people—their faces, their hands. And even though the faces I see in *Growing Season* are different—with Mexican field workers being the most prevalent guest worker population in the U.S.—the story is the same, and their importance to this nation is the same. Not only do they help fill our bellies, they enrich our economy and our culture.

In reading *Growing Season* and studying its vibrant pictures and tender stories, I'm reminded of Zora Neale Hurston's book *Their Eyes Were Watching God,* where in chapter 14 she describes how "day by day now, the hordes of workers poured in. Some came limping in with their shoes and sore feet from walking . . . all night, all day, hurrying in to pick beans." Those words go back to a time well before the lives of the people we get to know in these pages. That earlier vulnerability has given way to a dignity and respectability that informs the lives of the people and their families in this unique place, where the community is doing it right. Here are people who work hard and do well and who are treated with care and consideration by the grower whose land and crops they attend and by a network of people, churches, and organizations that support and care for them.

Here, then, is the heart and soul of working America as rendered by photographer Gary Harwood and writer David Hassler, both sensitively

skilled in their ability to link arms with those whose lives they aim to document. Here is a book that brings to our attention the way others among us live and work—and in so doing affirms what novelist E. M. Forster urged upon us: "Only connect." From the stories of these people that tell of their dreams, worries, joys, and sorrows, and through the stunning photographs of them going about their days and ways, we grow in our understanding of how our own lives are enabled daily. In a sense, Hartville brings us closer to the heartland of America—indeed, to its very heart and soul—and makes us most grateful students of this community and these people.

ROBERT COLES
James Agee Professor of Social Ethics, Harvard University

Introduction

When photographer Gary Harwood first received permission to photograph the migrant workers at the K. W. Zellers and Son, Inc., family farm in Hartville, Ohio, during the summer of 2001, he anticipated that he would be documenting hardship. Migrant workers continually face difficult conditions while trying to support themselves and their families. Farm work is physical, hot, and dirty. The days in the fields are long and exhausting. Growers can be brutal employers, and there is no shortage of documented cases of terrible living and working conditions.

In Hartville, however, Gary found a different story.

Here the workers and their families live in a strong, tightly knit community supported by the Hartville Migrant Center and many caring neighbors. About 70 percent of the workers return annually to this small northeastern Ohio town where they have established solid friendships and stable lives.

Over the next four growing seasons, Gary came to know and gain the trust of these Mexican American and Mexican migrant families who travel each year to Ohio from the southern United States and Mexico. From the beginning he displayed his photographs on the walls of the Migrant Center so that the entire community of more than 300 workers and their families could see what he found to be special and captivating about their lives. Though his work began with field photos, over time he focused more on family pictures, as he was invited to photograph baptisms, first communions, weddings, birthday parties, and private family events.

In 2004 writer David Hassler began collaborating with Gary on this documentary project. That spring, when the workers returned to the farm, David began interviewing the migrants as well as community members and volunteers at the Center. Working from the transcripts of his interviews, David wrote first-person narratives that speak with the voices of the people themselves.

We both understood that the success of this project required that we earn and maintain the respect and trust of the community. Throughout this process of collecting images and stories, we met often to share our discoveries and to see where our separate paths of work met and how each complemented the other, creating an unfolding and fascinating study of a people and place.

. . .

While documentary studies of migrant workers in the United States have more often focused on oppressive working conditions, *Growing Season* portrays the life of a community rich in social capital and gives voice in a new way to a group of people largely unseen and misunderstood. Our hope is that these portraits—in pictures and words—will deepen others' understanding of the migrant experience and perhaps offer an important contribution to the ongoing dialogue about migrant labor and immigration laws.

Within Ohio alone there are approximately 130 agricultural migrant camps tucked away and out of sight along dirt roads and on the corners of farm fields. Most migrant labor camps provide housing only for

single men, but some growers, like the Zellers in Hartville, allow entire families to migrate and, for those of age, to work together in the fields. In Ohio, and nationally, migrant workers have an annual net income of $11,000–14,000. Despite this relatively poor pay, seasonal work in the United States provides better opportunities than are available for these workers in Mexico and other Latin American countries.

In Hartville, the Zellers and other growers benefit greatly from a very active Migrant Center. Many of the year-long residents and members of local churches serve on the Hartville Migrant Council and volunteer at the Center. Nationally, there are few remaining migrant centers today that provide the range of in-house health, education, and legal services that Hartville's community does. In addition, Rural Opportunities, Inc., has been offering many services—such as ESL, citizenship, and home-ownership classes—to migrants in Hartville and other areas in the region since 1985. Without all of these services, the migrant community would struggle for many basic needs, for there are few legislative regulations that support or offer aid to migrant farm workers.

When the Fair Labor and Standards Act and the National Labor Relations Act were passed in the 1930s, farm workers were excluded from protections provided by these laws. Supporters in Congress had to accept these exclusions in order to attract the necessary votes from Southern members who opposed extending these new employment rights to mostly African American sharecroppers. In fact, the laws affecting farm workers today, though significantly improved, still pro-vide them far fewer protections than most other workers, reflecting a pattern of discrimination that reaches back through the era of segregation to the days of slavery.

The debate over migrant labor in the United States is as heated and relevant now as it has ever been. Congress continues to debate legislation that would provide various types of legalization or temporary guest worker status for migrant laborers, including farm workers. Some of these proposals contain provisions that would allow currently undocumented workers to earn legalized status and offer future immigrants a temporary "guest worker" visa and full labor protections for a certain time period, following which they could either return to their home country or establish permanent residency. The impetus behind these proposals is to give migrant workers the recognition and protection they deserve for their hard work and at the same time acknowledge their contribution to our national economy.

Understanding legal and economic issues concerning migrant labor is important, but it did not help us get to know the individuals who make up this community. *Growing Season* gives faces and voices to a people more usually portrayed in abstract and generic terms and more often defined by how they fit into a statistical group or political agenda. It is against a backdrop of this unique blend of Latino culture, mid-American influences, and untiring community support that we are able to see not just their working conditions but the spontaneous joy, dignity, and richness of their lives.

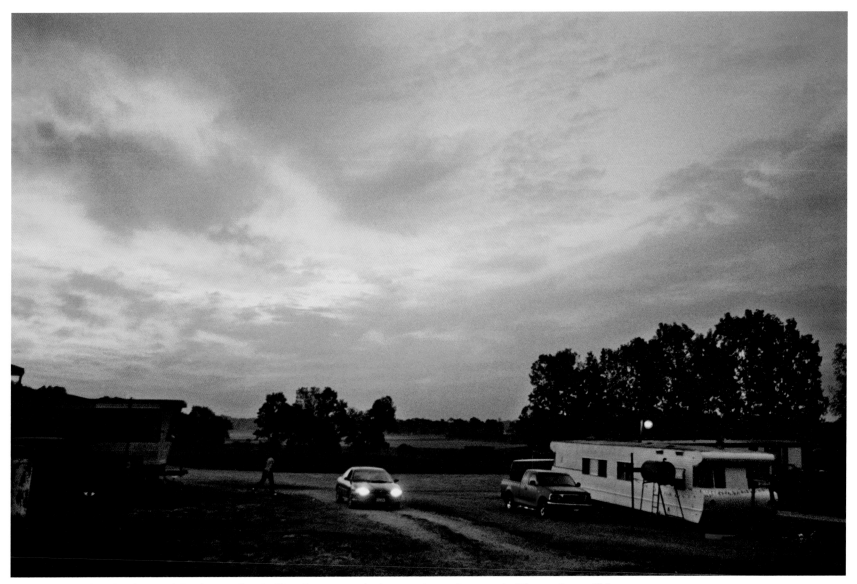

Families learn that the driver of the daycare bus is ill and cannot make her usual morning rounds. The workers will have to bring the children to daycare themselves before leaving for the fields, and they know that this can affect the departure time for the crews. It is a reminder of the important role each person plays in the daily routine of the farm community and of the balance between work and family.

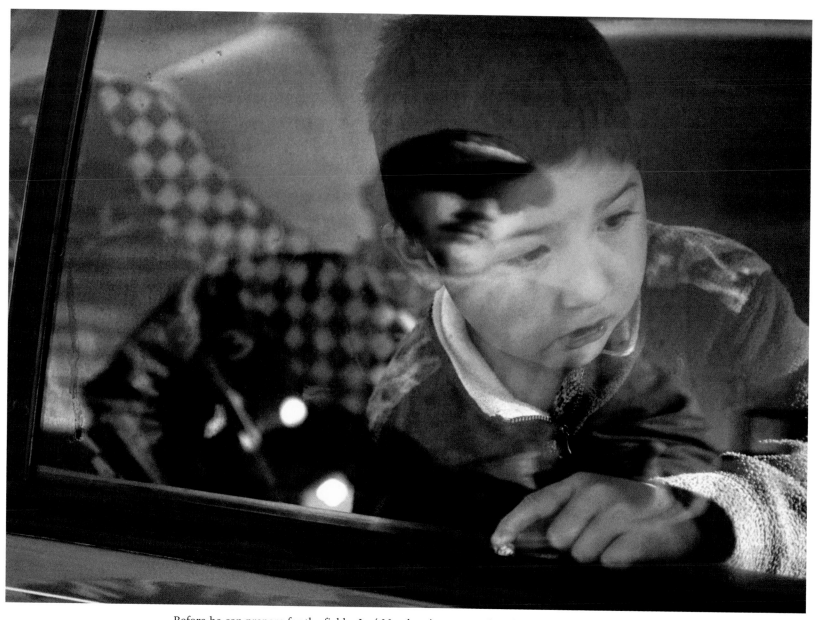

Before he can prepare for the fields, José Mondragón must get his children ready for the day. His reflection appears in the car window as he waits with his daughter for the school bus. His son, Virgilio, eagerly waits for his dad to come back into the car.

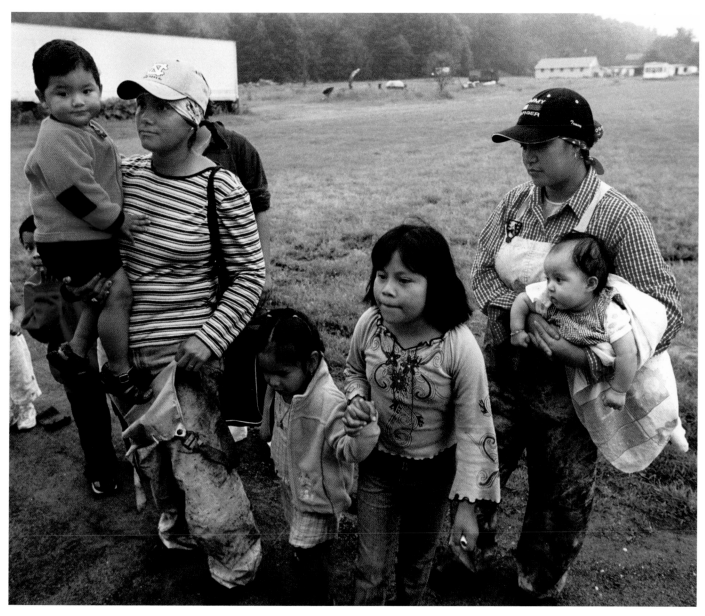

Because of the availability of quality daycare, more families have become established in Hartville. These women wait for the daycare bus to collect their children before the work vans take them into the fields.

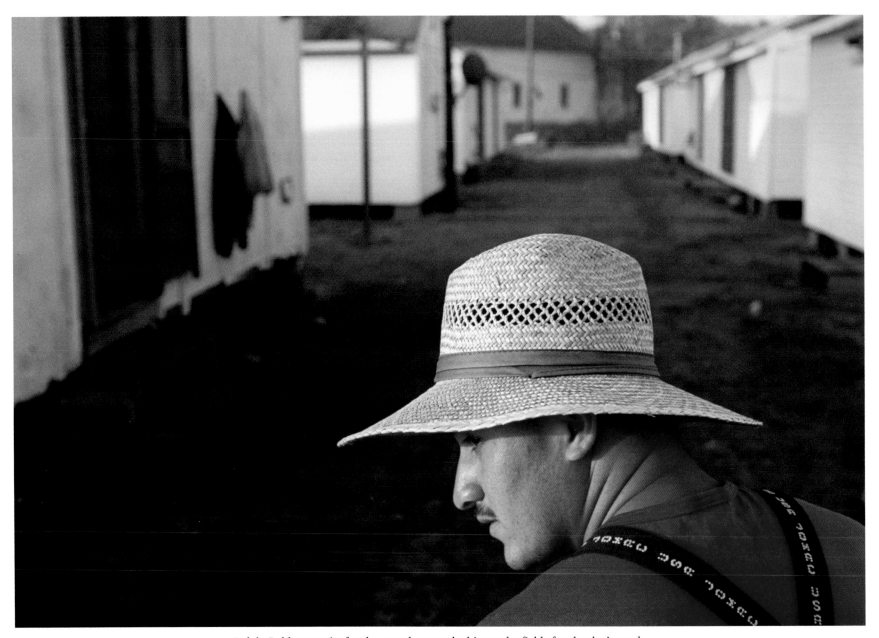

Rubén Balderas waits for the crew bus to take him to the fields for the day's work.

The warm glow of the morning sun lights up dew on the window of a work van.

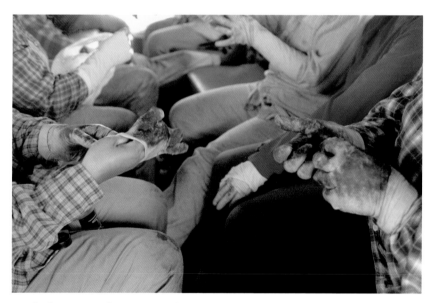

Inside the van, workers prepare for a day in the fields.

Muck Fields

What was once swampland left by the glaciers and drained in the late 1800s is today rich farmland. Here, at the Zellers farm in Hartville, Ohio, this incredibly fertile, black muck soil can support as many as three harvests during one growing season.

The wet, black muck acts like a dye, staining work clothes, boots, gloves, and skin. The dark soil soaks up the sun's rays and creates a steamy environment much hotter than forecasted conditions. Workers must wear protective rubber pants, gloves, and boots, which intensify the hot conditions in the fields. Sometimes the growers will pull the workers from the fields when the heat is extreme and always if there is lightning or severe storms.

Though drought can be challenging for most farmers, the growers here can manage it by tapping an underground aquifer that runs directly beneath the farm. The water is directed to the fields through irrigation pipes. Because of this limitless water supply, growers have control over how much water the crops receive. This irrigation, combined with the fertile, black muck soil, makes conditions right for lush and beautiful crops.

To manage 500 acres of fields and harvest more than 45,000 crates each week, the crews must work with skill, efficiency, and, above all, speed. The workforce at the Zellers farm includes seven cutting crews, three blocking crews, an irrigation crew, tractor drivers, and those who work in the wash house.

Cutting crews are paid based on the volume and condition of the produce that they place in the crates. Blockers are paid based on the number of rows and the types of crops they weed. Other farm workers, such as those who work in the wash house, are paid an hourly wage. The cutting and blocking crews each consist of approximately 10 workers, including a foreman and a driver. In some cases, the crews are made up of members from one extended family.

Crops are harvested based on demand. The foreman ensures that the orders are filled properly and tallies the productivity of each worker. Because workers in the crews are paid based on volume, they essentially monitor themselves. A worker who is slow or damages the fragile crops when packing the crates decreases the productivity of the entire crew. This system for determining wages creates a strong sense of teamwork within the crews.

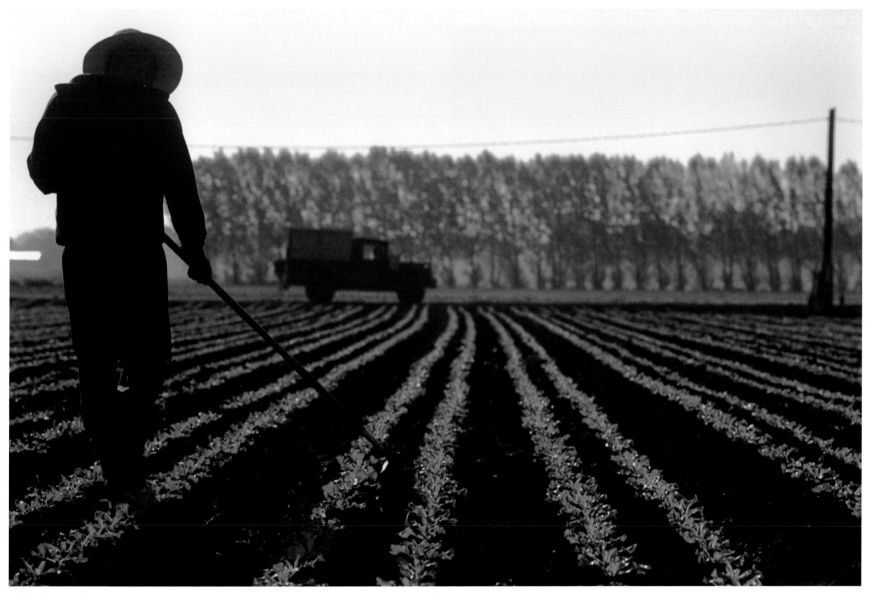

A blocker works the black muck soil. Blocking involves removing some plants in order to give the remaining ones more room to grow.

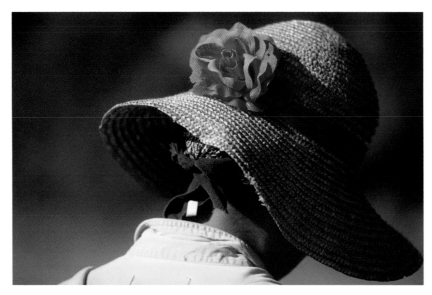

Migrant women dress for the fields. They commonly wear necklaces, earrings, bandannas, and brightly colored flowers or bows on their hats to distinguish themselves from other women in the fields, with each hat offering a bit of her personality.

A worker cuts parsley and bunches it by pulling rubber bands from his fingers and, in a twisting motion, tying the plants together. This happens quickly and fluidly as he works his way down the rows. The faster and yet more carefully he harvests, the more money he can make, since he is paid by volume and quality.

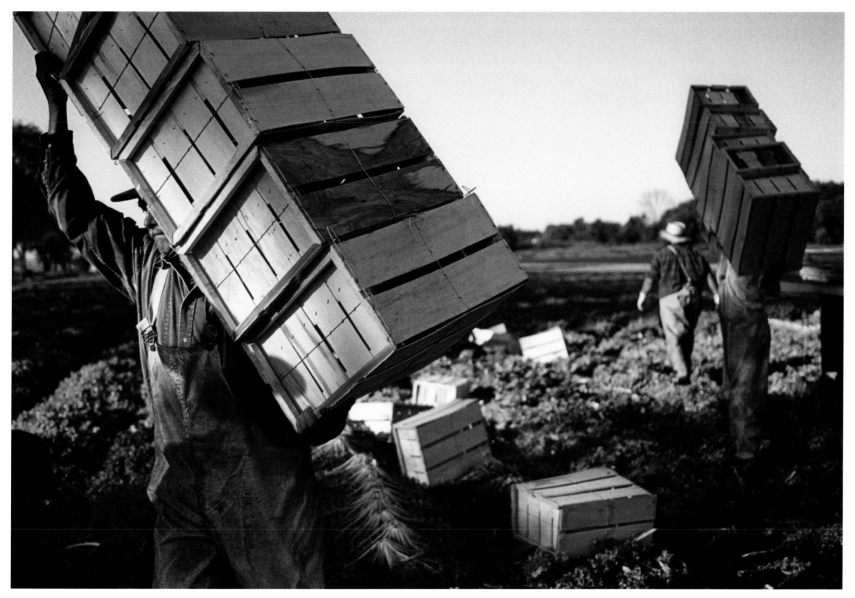

Workers move crates from the trucks to the fields, where they'll be packed with fresh lettuce and placed back on the truck for delivery. Because lettuce can wilt in the summer sun, the filled crates are quickly delivered to the wash house where they are cleaned, cooled, and placed in cold storage.

Beatrice Gutiérrez

My day starts at about 4:50 in the morning. I get up and make some tortillas. Then I make some tacos to take out to the fields for our 10 o'clock break. We like to eat our lunch then so that we can come back here at noon during lunch and just rest for an hour.

I'm the only woman in our crew, but I'm the crew leader. I get the report of where we're going to work before I drop off my kids to catch their school bus. Mostly everybody on our crew is a family member from my husband's side of the family. We are blockers. We block the kale and romaine and red leaf lettuce and make sure the plants have enough distance to grow, so when they're harvested they are big enough to cut and send out to the stores. And the red beets, cilantro, parsley, and onions we weed.

Since I'm the crew leader, I figure out how much we've done at the end of the day and divide it up between everybody in our group. I'll say we finished 15 or 20 rows each at $2 or $3 a row. I add it all up, and sometimes we make $70 or $80 per person for one day. At the end of the week, we have something. Some weeks, among my husband, son, and I, we can make $1,200 as a family and save $600 of it.

I've always been in migrant work. My father was born in Mexico and my mom was born in Texas, and I grew up in Florida working with my parents in the fields since I was small. Back then you could start working before you were 16.

We've been coming to the Zellers farm for 12 years now. They always give us the same place. That's what we like about it. We feel more comfortable not having to move around every season. On Saturdays our work ends at noon. As soon as it ends, we come and take a shower. Sometimes we go shopping. I love to go to garage sales in Hartville or to Wal-Mart. They have everything cheaper there. On Mondays I'll go to the Migrant Center thrift sales. Wednesdays I usually go to Bible study at the Migrant Center. Sundays I still get up early, seven at the latest, so I can start washing all the clothes. I usually don't finish until 3:00 or 4:00 in the evening. And when I'm done, I sit down and rest, and I don't want nobody bothering me.

I'm not ready to retire yet. I still want to work. I just had a baby on May 12th. Now I have four children, two girls and two boys. I want to see our children get their education first. They have it both ways. We go down to Mexico after the season ends here, and they go to school down there. My son wants to go to one of the army bases and become a mechanic. I tell him that's okay by me, as long as he finishes school. I'll make sure he don't get married first. I always tell him that and not to have a baby neither. 'Cause if you have a baby, then you have to keep on working, and that is a big obligation.

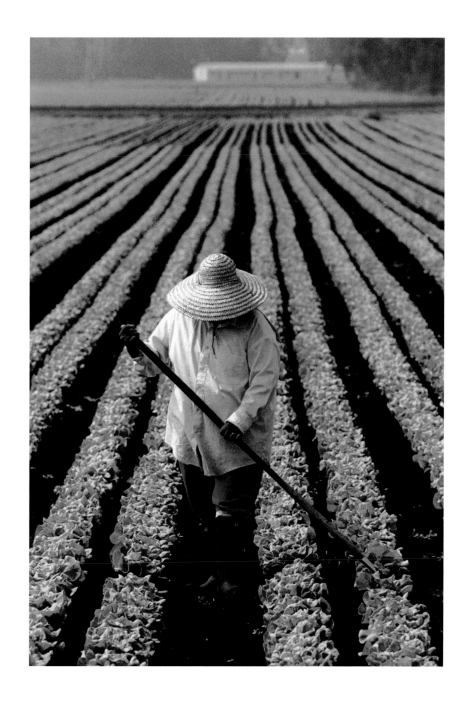

Beatrice Gutiérrez blocks rows of leaf lettuce on the Zellers farm. One of the migrant housing facilities available to those who work on the farm is in the background.

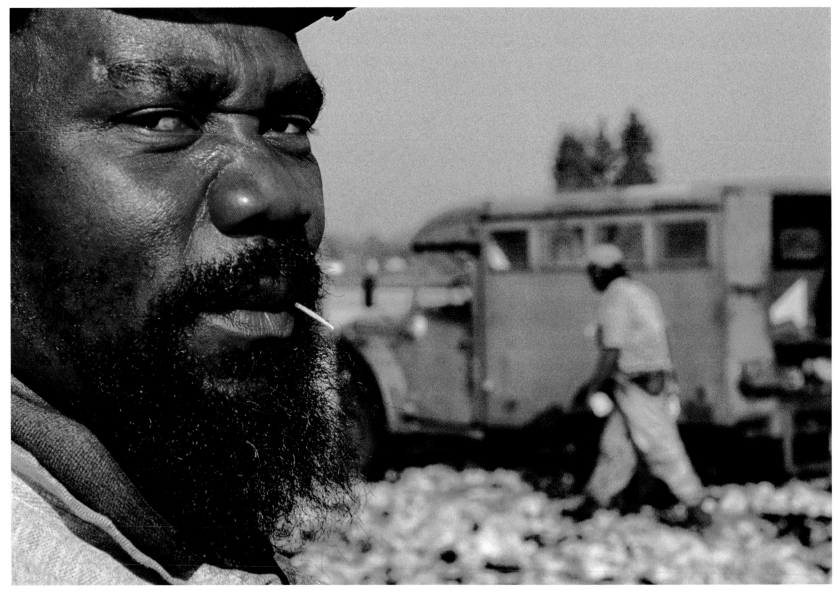

Jamaican migrant worker Winston Warren has worked at the Zellers farm for more than 13 years. He is one of the few non-Hispanic migrant workers assigned to a harvest crew. He also lives in migrant housing supplied by the growers. During the early 1940s, Jamaican migrants were the primary source of labor for Ohio farms.

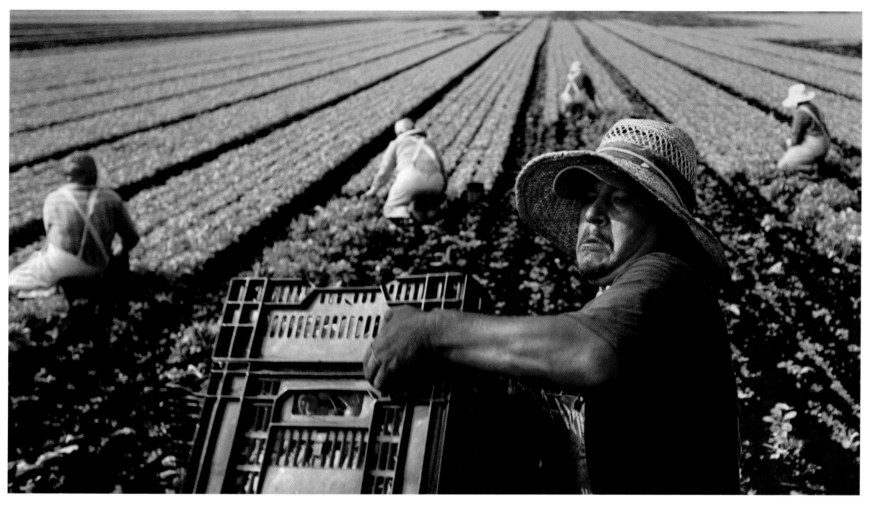

Once the radishes have been harvested and placed in crates, José Luis Zavala breaks from his row and helps stack the crates on a flatbed truck. While the driver of the truck slowly backs it into place, workers walk alongside putting the crates onto the flatbed. Others in the crew remain in their rows and continue to harvest.

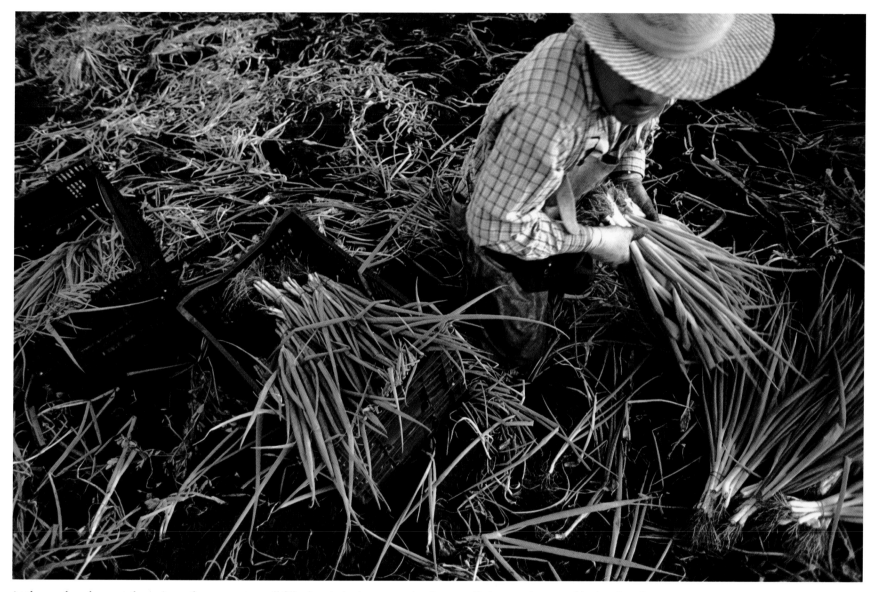

As the workers harvest the onions, the pungent smell fills the air during a morning harvest. Onions are harvested by hand and the outer layers are removed in the fields before they are bunched and placed in plastic crates.

Iván Soto

I learned English almost by myself. I would practice an hour and a half every day after work. A lot of people prefer to listen to music or sleep, or kill time with other things, but that is what I did. I learned a lot of words every day that I tried to keep in mind. And I talked to American people. If you want to learn, you can little by little. I tell everybody we're here in the United States, so we ought to speak English.

My dad was the first of us to come here 10 years ago. The next year he came with my mother. Then two years later all of us came. Now we work together in one crew: my mom, my dad, my brothers, my dad's sister, and my cousin. It's nice to work all together with your family. Sometimes when we are very busy and have a lot of weeds, we're silent. We concentrate and just think about what we are doing. When we are not too busy, we have a little bit of time to be talking while we work. We talk about too many things—things that we did a long time ago or things about Mexico. It helps a lot, but the work still is hard, especially when it's hot.

This year I asked my boss if he could give me a small house or something like that, because I am waiting to bring my wife and son. He gave me a place next to my parents' house. I have two rooms, a bathroom, a little living room, and a kitchen. Right now my wife is down in Mexico with my son. He is one year and eight months. I am waiting for some forms to get my wife a resident card. A lot of people come to the United States illegally, but I don't want to do that for my family. I don't want to take that way.

Four years ago I went to Akron to start an application to get U.S. citizenship. They asked me a lot of questions and then nine months later sent me a letter saying that I could apply for citizenship. When I went to Cleveland the officer called me to his office. I think maybe he was from the Philippines, because he spoke Spanish fluently. He seemed angry and told me in Spanish, "I'm sorry I was checking your notes and you don't have the right time living here in the United States, so you have to wait more time." But I know I had the right time living here. He said, "If you want to do the test, you can do it, but it's not going to count." He was talking to me in Spanish like he was mad.

Later, I was checking all my papers, and I was counting the months. I know you have to have 30 months—and I counted 35 months. The lawyer who I went to in Akron asked what happened with my case. She sent a lot of letters to Cleveland, and she never received an answer. She told me I should put in a new application, so I did, and I had to pay again.

The next time I received a letter I was in Mexico where we live, 12 hours from the border. I took a bus all the way here and stayed with my neighbors, Bob and May Nichols. I told Bob and May I have to study the questions. I know only 30 of the easy ones, but I have to know 100 questions about the amendments, the Bill of Rights, everything. Who is the first president? If the president dies who's gonna be the next president? How many stars have the flag? How many stripes? What do the stripes mean? Questions like that are the easy ones.

The next morning I went to Cleveland, and it was a very different person than the first time. She was a lady about 27 years old. She asked me my name, when I was born, and then said, "Are you ready?" I said, "Yes." So we went to a room and she began asking me questions. There was a camera beside a big table recording me. Somebody told me she was gonna ask about 20 of the 100 questions, but you don't know which ones. She asked me 13 questions, and I knew all 13, so she stopped asking. Then she said, "Are you ready to write something?"

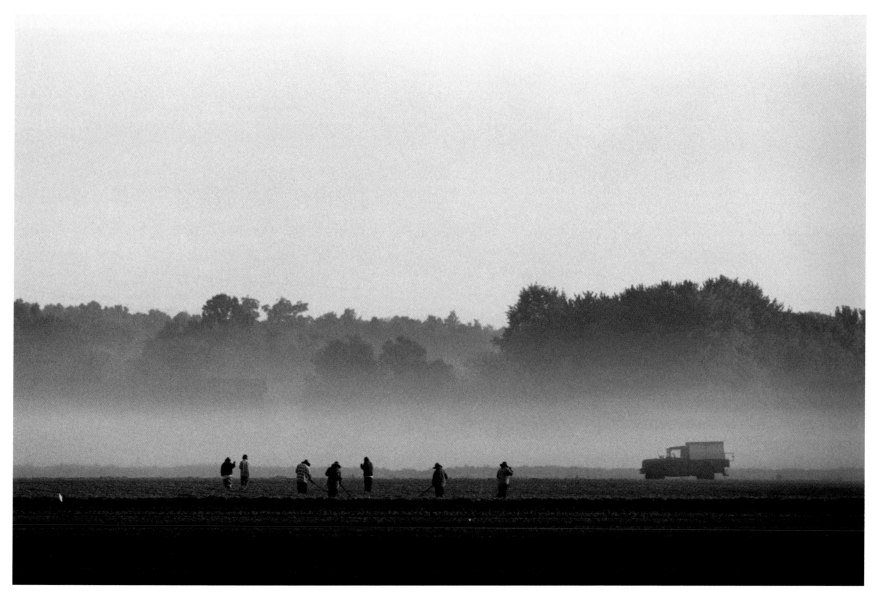

The Soto family was one of the first Mexican families to become established on the Zellers family farm.

"Oh yes," I said. It was something very easy, like, "I live in the State of Ohio."

The official ceremony was May 10th at the Palace Theater in downtown Canton. I wore a suit. They never talk about it, but somebody told me you have to wear a suit. We were 30 to 35 people from different countries. I know there was two persons from England and a lot of people from Russia, but there was only one from Salvador and only myself from Mexico. I don't know where the other people were from. We were all on the stage seated in chairs. There were probably like 200 people in the audience, family and friends and other persons, and students just looking to see the process.

We had to hold our hand up and take an oath. We had to promise to fight if there is a war, to protect this country. We were all together repeating after a person with a microphone. Then they gave us a certificate one by one, and we shook hands with about five different people. When we were finished, I gave my green card to a man, and he had me sign a citizenship paper. Then they gave us a sandwich and some fruit and we talked to people. I know the mayor from Hartville was there. I have a picture with him. I don't remember his name, but he told me, "Whenever you want to come to my office, we can talk a little bit." But I never did that.

My family was happy when I got my citizenship. But that day I went back to work like a normal day. I lost a lot of days of work because I went two to three times to complete the form in Akron. It was a lot of money for the application, too, and I had to put in an application twice. I was counting the money I paid—the lost time, the fingerprints, and the letters—and the amount is probably about $3,000. It's a lot of money and time, but it was worth it. I have what I was fighting for.

I've been a citizen now for two years and four months, and I received a letter two months ago where they said they know everything about my wife and are ready to give her a green card. They are gonna send me a form to tell me where I have to go to meet her—to which bridge, which border—and what I have to do. That is what I am waiting for now.

One of my mom's brothers put in an application with a lawyer in Houston, but now he has his family here. They are residents already for four years. But they received their green cards before the terrorists sent the airplanes into the World Trade Center. That is why they have their green card in 10 months. Now they say you have to wait two to three years.

Someday I want to have my own business and not work for anybody else. If I can, I would like to have a mini-market or something like that. Maybe someday when I'm old, my family can live back in Mexico. But now I am young, and I know I have to work here for a lot of years.

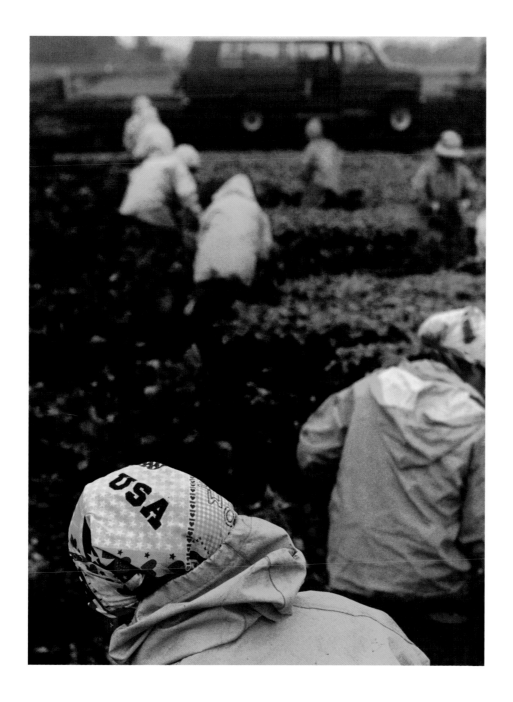

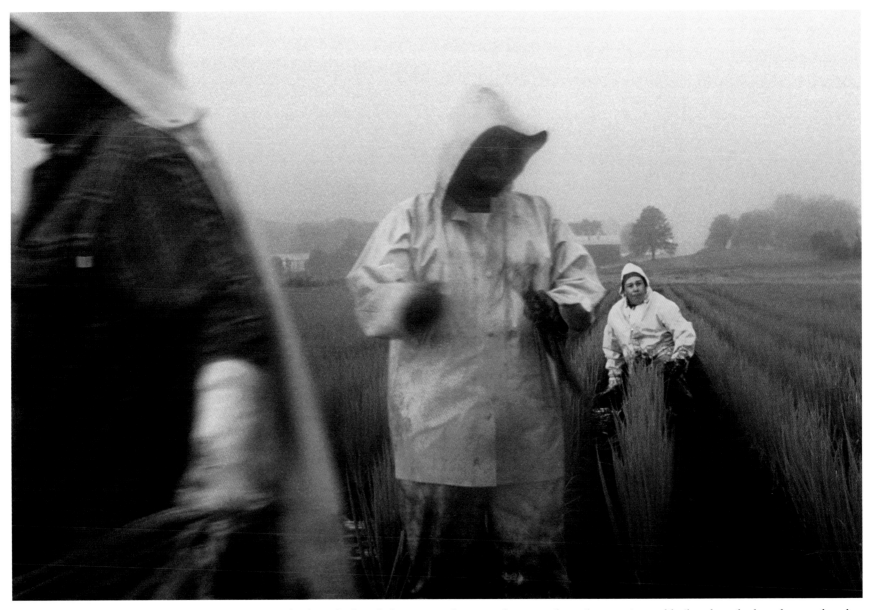

Mariana Delgado and others in her crew rush to complete an order as heavy rains and hail replace the hot, dry weather that lasted nearly two weeks. Enduring extreme weather conditions is a part of farming and a reality for migrant workers.

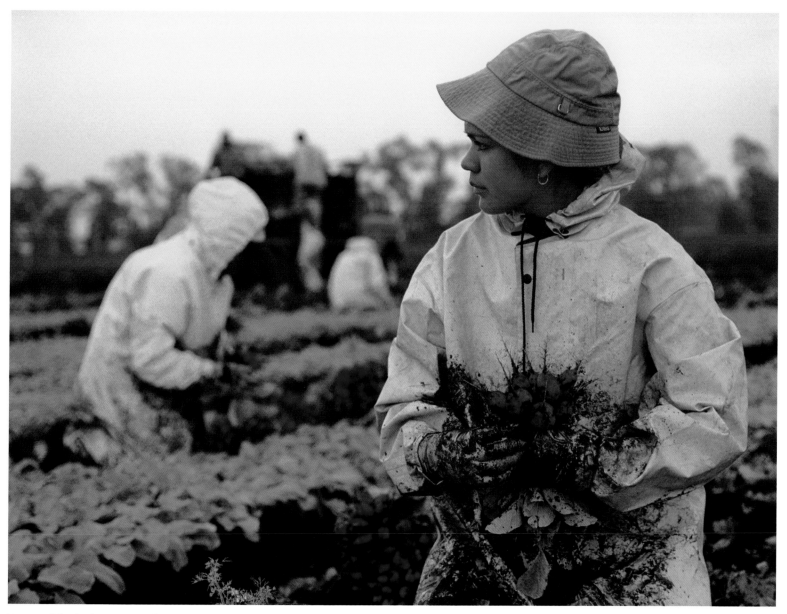

Prepared for inclement weather, Patricia Prieto works with her crew to harvest radishes during a morning rain. Because radishes can withstand cool temperatures, they are an ideal crop for planting throughout the growing season.

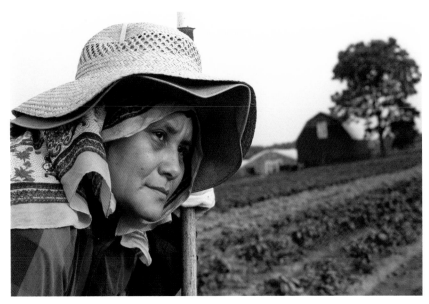

In an effort to shield herself from extreme heat and humidity, María Cristela Rubio wears two hats, a bandanna, and layers of clothing to protect her from the sun.

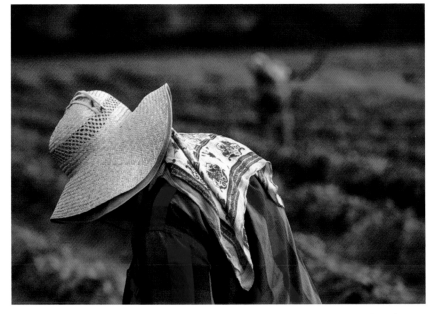

Even though she was pulled from the fields midday, the heat ultimately takes its toll, and her posture reflects the effects of a full day in the fields.

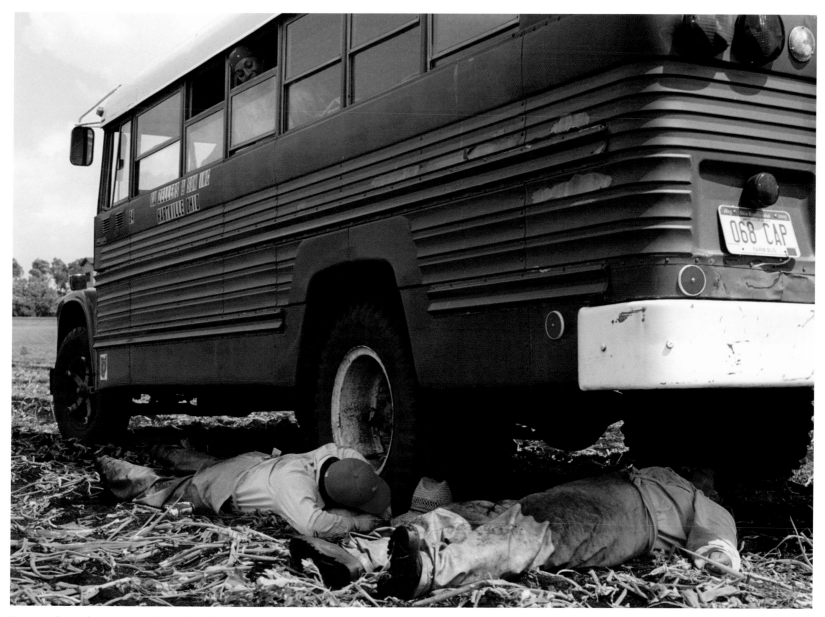

During a late-afternoon break, workers find the shade from their parked bus the only source of relief from the heat and humidity of a midsummer day. Workers take three breaks during the workday, including lunch.

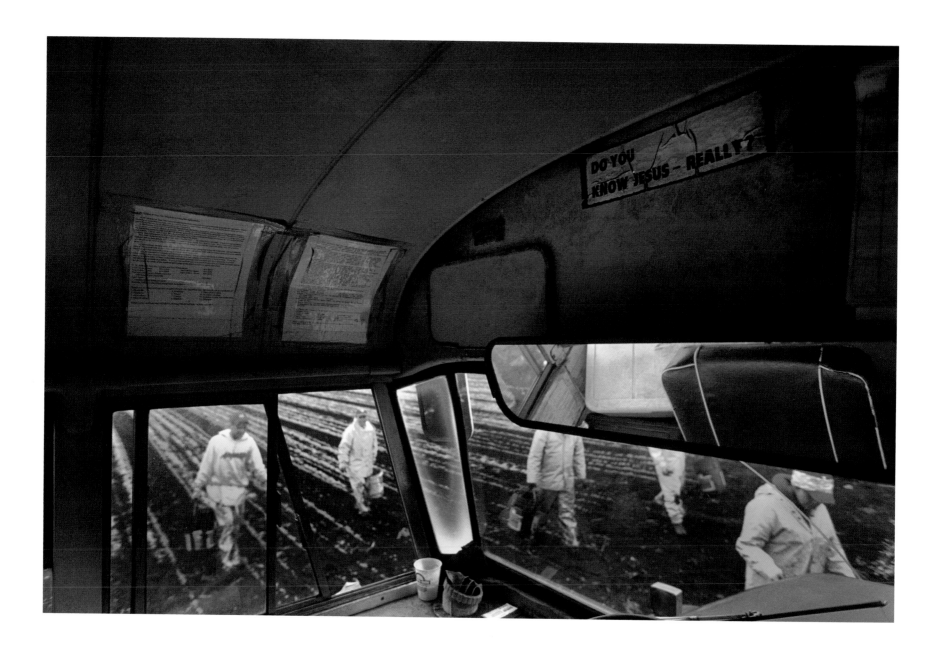

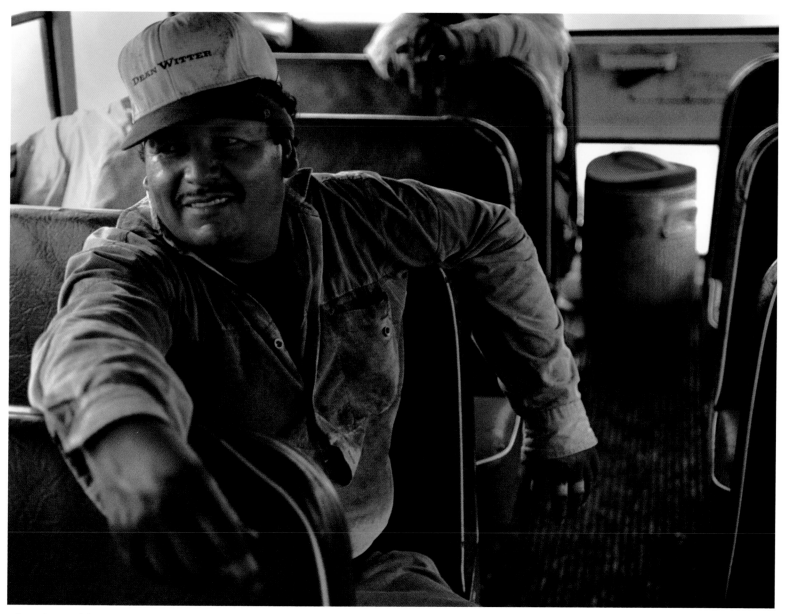

After a hot and humid day in the fields, Jesús García and others in his crew are transported back to their homes on the perimeter of the farm. During the work hours, trucks, vans, tractors, and buses are in constant motion.

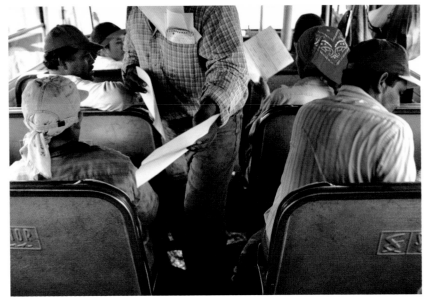

With his hands still covered in the muck from the fields, the foreman distributes paychecks. Friday is payday, and the checks are distributed on the bus before he returns the workers to their homes.

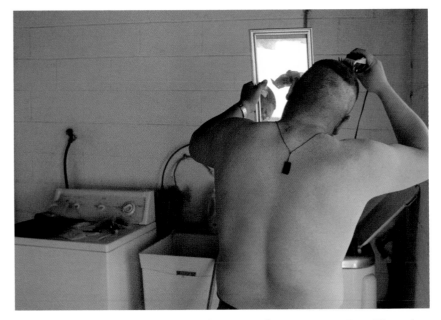

In the area just outside the shared bathrooms in the Tope Camp, Juan Pérez gives himself a haircut after a long day in the fields.

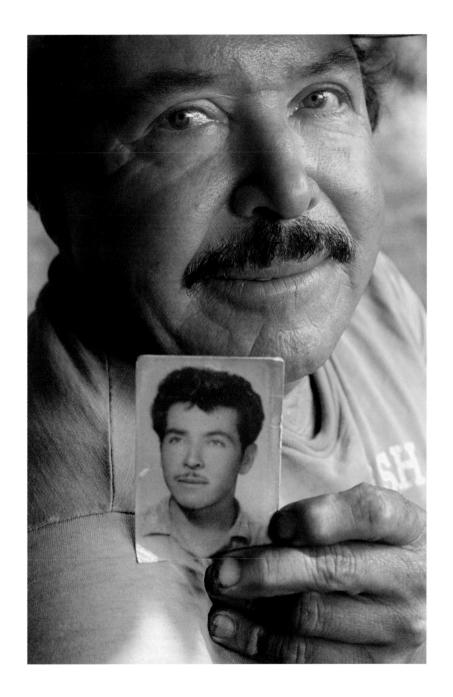

Jacinto Martínez displays a photo of himself as a young migrant worker. He has been a farm worker in the United States since he was a teenager.

Wash House

For most of the migrant workers, the workday begins at the wash house. An expansive brick and metal building, the wash house contains large hydrocooling machines, washing tanks, long metal conveyor belts, multiple loading docks and delivery bays, as well as the farm's business offices. It is the hub of all activity on the farm. Early every morning, crew members gather at the wash house to collect the supplies that they will need, and the foremen receive the harvest orders for the day. With supplies and orders in hand, the crews return to their vehicles and scatter to the fields.

In the wash house, workers prepare vegetables for market. They find their places in the packing line as the hum of engines begins and water circulates in the washing tanks. One section is dedicated to preparing leafy vegetables. Here, the vegetables are cleaned, packed, stacked, tagged, covered in ice, and placed in coolers. In a separate area, onions and radishes are prepared for market in a similar manner. Radishes are topped mechanically in the field and then brought to the wash house where they are cleaned and transported to workers who sort, bag, and seal the bright-red roots.

For the rest of the day, vehicles routinely enter and exit the wash house. Trucks bring in the freshly harvested vegetables, while clients wait at the loading dock for their tractor-trailers to be filled with the produce that is transported to supermarkets and wholesale warehouses throughout the eastern United States.

Before returning to the fields, workers wait inside a work van while the foreman gets his harvest orders.

Jeff Zellers

My grandmother and grandfather started the business back in the 1920s. During the '70s and early '80s, a lot of other small family farms around here were being sold. In many cases the younger family members didn't want to continue the work. I actually had intentions of going to law school, but in 1987 I was given the opportunity to come back and join the family business, and I took it. We needed help with sales, marketing, and finance, and since I have a degree in economics, it seemed to make sense.

All of us in the family have very different talents that we bring to the business. That's part of our success. In the last 20 years we've been able to purchase more land as other farms have gone out of business, and we have added nonfamily members as key employees. We're now rapidly entering into the stage where it's the third generation running the business, and the third generations of businesses are the ones that usually have the hardest times succeeding. We've got that in front of us right now.

We grow all kinds of leafy lettuces, radishes, green onions, and herbs, such as cilantro and parsley, and we ship our product all over the eastern United States. About 35 to 40 percent of that product goes to wholesalers, terminal markets, food service outlets, and the balance of it goes directly to retail chain warehouses. Our customer base remains pretty much the same year after year, much like our employees, about 80 to 85 percent consistent.

My cousin, David Zellers, works directly with our labor in the field. In order to communicate well with our employees, to speak their lingo, he went down to Mexico—not along the border but well into Mexico—to learn Spanish, even though most of our crew foremen, and a lot of our key people, speak English also. I always joke that our employees' level of English-speaking comes up or goes down depending on the day and how much they want to know or not know. We usually just laugh about it and go on.

Family is very important to our workers. There are pluses and minuses to having such large extended families here, but for the most part we think it's very positive. When they arrive, you know that they are here and are not leaving until the family is leaving. That is great. The other side of it is you have the potential, say, that a crew leader can make his mother-in-law unhappy because his brother-in-law is not carrying his weight today on the crew. There are challenges for those foremen when those types of things occur, and sometimes we have to move people around. But having the whole family here definitely reduces trouble. We do not deal with as many conflicts as we used to, I believe, because of the family unit. And religion plays a very big part in their lives, too.

I shop in the same grocery store that they do on Sunday afternoons. These people are very proud, so when they go to the store on Sunday, they're cleaned up, dressed up, and very respectful. They are a big part of the economy in this town. Between ours and another farm, there are more than 300 people here in the summer. If all of them are shopping at the grocery store in Hartville, or even half of them, it adds up.

These people are very proud of their work, too. That doesn't mean that there aren't days when they are angry with K. W. Zellers and Son or when K. W. Zellers and Son is not happy with the work they are doing. Same as any other employer. But from my standpoint, I've always taken the attitude not to treat them like a seasonal or migrant laborer but simply a laborer, a valued employee. There is an expectation for them to do their job—and if they are doing it well, we are going to wholeheartedly treat them the best we can.

Up until 15 or 20 years ago, we had primarily African American and Jamaican-descent workers. I grew up with many of the migrant

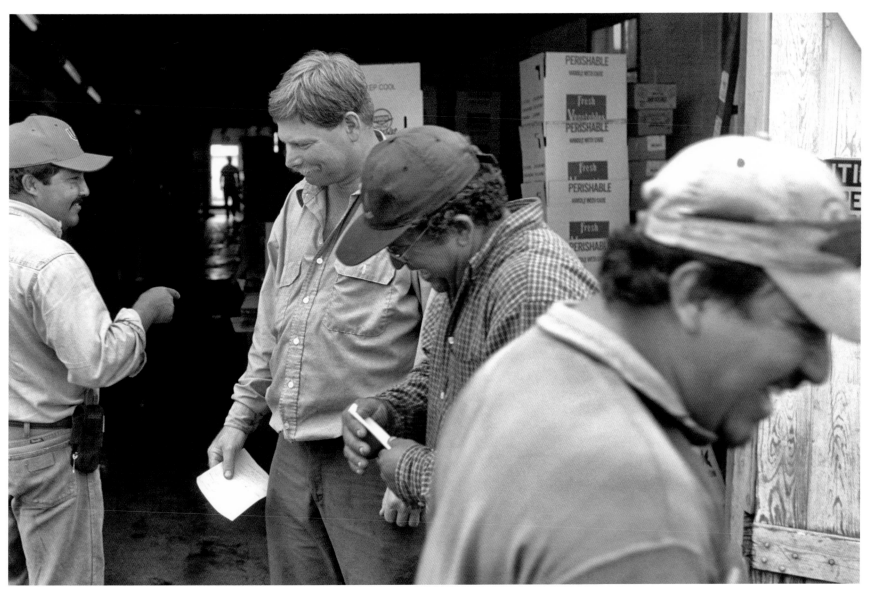

A foreman and drivers share an inside joke after receiving their afternoon harvest orders from grower David Zellers. It's been a good year for the crops. This may mean longer hours for the workers, but it's also an opportunity to make money.

children and went to school with them during the fall and late spring. The Migrant Center would pick the kids up on a bus and take them swimming in the afternoon. It was all volunteers who had a sincere interest in seeing that these kids had the same opportunities as the others who live here. They didn't want these children to be left at home or, certainly, because of labor laws and safety reasons, dragged around in the fields.

Hartville is a unique community, because for the most part it is a middle- to upper-middle-class, white, Anglo-Saxon community. But for 20 weeks every year, between late spring and early fall, it has this large minority population. If you go back a generation or two, these workers were very much part of the life here—everybody knew about them because so many people had a tie to agriculture. Today, a lot of people can't understand why all these Spanish-speaking people are here. They don't realize our farm is located so close to Hartville. They've lost touch with how their food is grown and how it comes to them.

There's a great misconception that when these people come into our country they are actually taking jobs away from citizens. But most of the jobs in agriculture are not going to be done at any pay rate by the remaining people that are unemployed in this country. It is just a plain reality. We've hired people and watched them come and go. We do have some local people who are great employees, but we will go through 20 in order to find one. The work we do here is specialized, and the crops we grow are labor intensive. We need people that know how to harvest and pack them.

There are times when I will walk out with a packed box that's unacceptable. I'll dump it out on the truck and stop the crew, which is painful to them, because it's costing them money. But I'm doing it to make a point, to say, "Look, our customers are ready to fire us because we're not doing this right." The crew foreman who comes and says, "This is what I'm going to do. I'm going to put a number on everybody's box, and that way in the packing house we'll know who is doing a good job and who is not"—that person is working for us. That person has the same level of integrity and respect for K. W. Zellers and Son that we try to have for them.

This is not your typical grandparents' farm from the turn of the century, with 5 cows, 5 pigs, and 10 chickens running around. Economically, we have a very narrow window in which to do a lot. We have a huge investment in the facilities, the equipment, and in the housing for these people. Things have got to click and work. We house about 150 people that work for us, plus their families. All of our housing goes through a licensing process with the State of Ohio. Each year the Ohio Department of Health licenses our labor camps. It can be a challenge because we must provide a certain amount of square footage per person. Ideally, you want both a husband and wife to work if you are providing housing. So we have to be aware of the economics of this.

Some years the Immigration/Naturalization Service comes and looks through our paperwork. They'll take it with them. They look to see that it's filled out accurately. Our role as an employer is just like any employer. We fill out an I-9 for every worker; they can be in Category A, B, or C. We don't want to hire people who three weeks later have to leave because Immigration/Naturalization comes in and says their paperwork doesn't work. That has never happened to us. So we look to see that their paperwork is not tampered with and that it's the proper information. And if everything checks out, we hire them.

In the past when we've had a situation of extreme drought, it draws the media. They want to do a story on the drought, but it only takes about two minutes to get right to the heart of what they really want to talk about: how many of these poor people are starving right

now because of it? I have become very calloused to the media and their *Grapes of Wrath* mentality. I tell them to talk to me in November. If you want to know how the drought affected my farm, talk to me when I'm done. That's not really what they are looking for.

The immigration issues are challenging since September 11th. And they are going to continue to be so. I know the Department of Homeland Security has stepped up border patrols, and that's great. From a terrorism standpoint, I don't mind taking off my shoes and belt when I go through the airport. I want to know when I get on a plane that I'm safe. But there needs to be a balance. We can't do everything under the fear of terrorism and lose sight of the fact that many industries, beyond just agriculture, need a stable labor force in this country. I think this message is being lost. It's easy to grandstand, to stand up in front of the cameras as a congressman and say, "I'm going to do everything to close the borders." But we have to balance our need for labor in this country and for resources with a high level of security. I think it's important that people recognize these folks are here and to not turn their back on them. Don't say you're going to close the border. These workers simply want to come here and make a better life for themselves.

Some of our workers, I know, are saving money to build a house in Mexico. The earning power of what they make here is tremendous when they go to Mexico. When you have workers that take their family and move back there and live permanently because of the money they've earned working for us, is that a bad thing? You have to replace that person, and replacing an employee is expensive and risky. But on the other hand, I'm not going to be mad at someone because they've made a better life for themselves. I like the human element, but all this makes sense from an economic standpoint, too. If we don't have a good, consistent workforce, we're out of business. And if we don't take care of our workers, they won't come back, and we'll have to retrain 160 people every year. I'd like to change people's perceptions, so they realize these workers are a viable part of the economy—and not just in Hartville, Ohio.

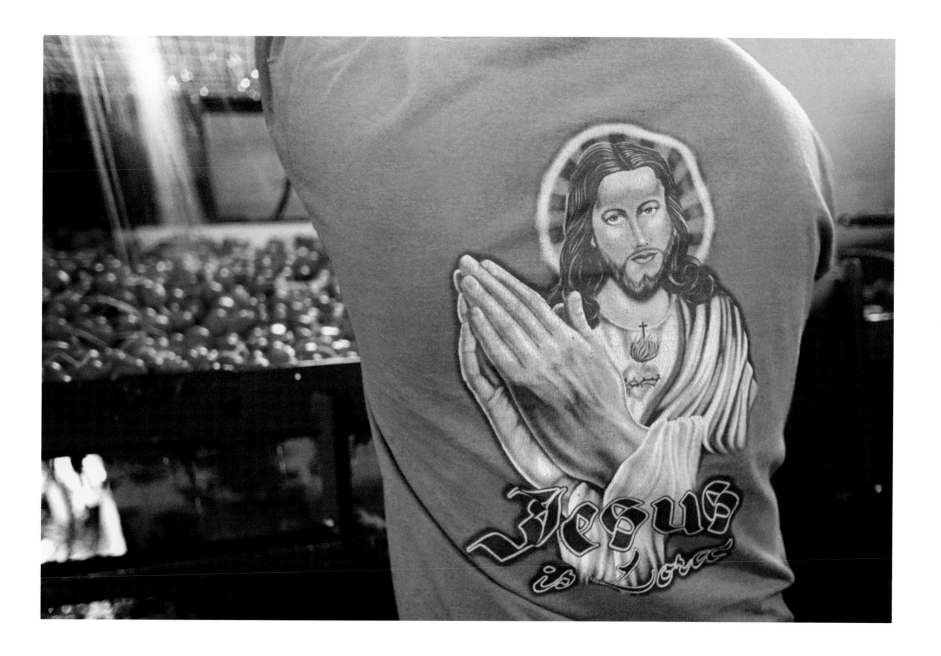

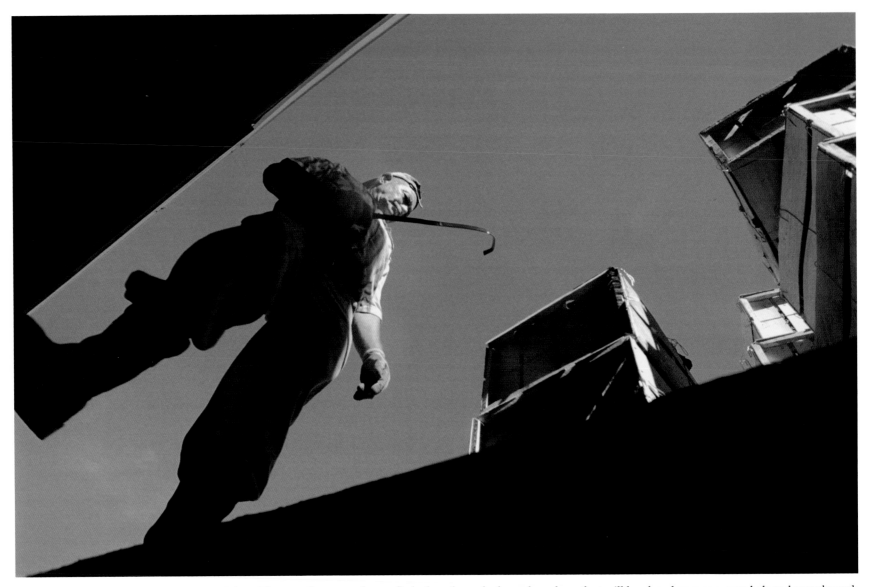

Víctor Rico transfers crates from a flatbed truck to a hydrocooler, where they will be placed on a conveyor belt and sent through the frigid water to be cleaned and cooled. Leafy produce can wilt after a harvest, so it is important to cool and ice the crates as soon as they enter the wash house. Víctor uses a metal claw to bring the crates closer before placing them on the line. This is Víctor's first year in Hartville.

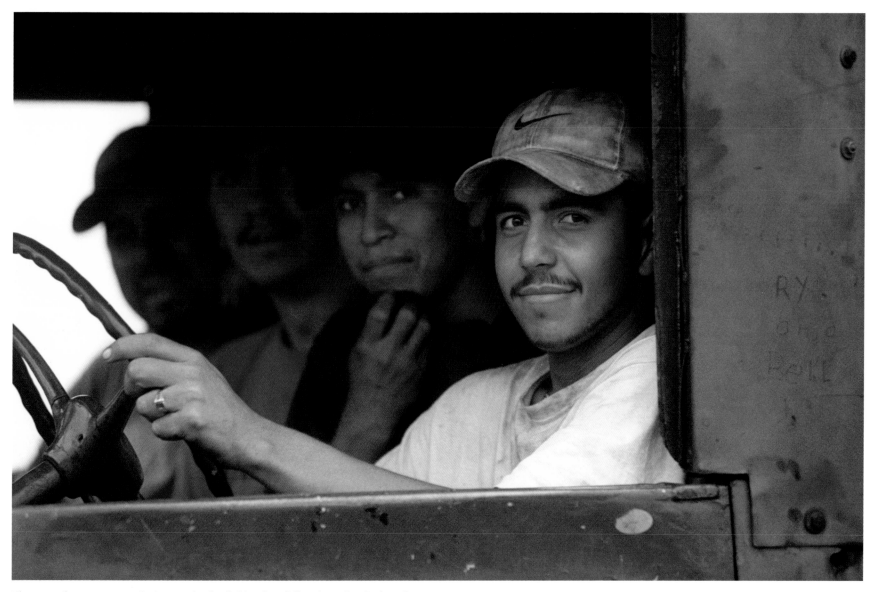

These workers return to their crew in the fields after delivering a load of produce.

Eric Romero

My parents came to the United States about eight years ago, just after President Salinas left office. At that time inflation was out the roof, and my dad had lost his job as an accountant at a very large bank. He was one of many people in Mexico to lose their jobs then. We had a nice house, not big, but comfortable, but it was a hard time, economy-wise, and he was really scared. He didn't think we could make it. So he and my mother decided to sell everything they owned and to come here to start over.

For the first three years they were here alone. They would work in Florida during the winter and then come to Ohio during the summer. My brother and I stayed in Mexico and lived with my grandma for a year, then my uncle for the next year, and then my grandma again. My parents would call us almost every day. They'd ask how we were doing and tell us they were fine and that they missed us. It got a little hard sometimes, a little lonely, but it was just three years.

It must have been a tremendous change for them. My father was used to wearing a suit and tie to work, and my mother had always stayed at home, but now they both worked in the mud and the rain. They didn't care where they worked. My father has always told me that the thing he cares most about is making a future for his kids. He says he will never give that up. He'll work until his last drop of blood to see that his kids can succeed. So we're not going to let him down.

My brother and I came here five years ago when our parents were ready for us. They were renting a duplex in Hartville. I was almost 14 years old and couldn't speak a word of English. The funny thing is, I was suppose to start sixth grade, but they gave me a test, with mostly math and science and not very much grammar, and somehow I passed it. In fact, I got such a high score that they put me in seventh grade. So I skipped sixth grade without really being able to speak English!

Well, it got harder and very frustrating, too, because people would come up to me and say, "Hi, Eric. How are you doing?" and I couldn't say a thing. I would just nod my head, not knowing what they were saying. My favorite five words were, "I do not speak English." They would just look at me and walk away. Then I got a little bit better and began to learn the basic stuff and eventually got to the point where I could practice my English. People often thought I was saying something else, but somehow I got through.

When I went to Marlington High School people warned me that there would be a lot of rednecks there and that I should be afraid. But everybody was really nice. Students would just come to me and say, "Hey, you need help? What do you need?" My math teacher, Mr. Locke, knew a little bit of Spanish, and he would sit with me during class and teach me English. I had four lists of vocabulary words, and I would study them every day.

The migrant counselor at the school, Mrs. Austin, was one of the nicest and best teachers I've ever met. There was a time in our schedules when all the migrant students would go to her room for a kind of study hall. She would help us with our homework. And those students who understood English would help the others. It was a good time to just sit down with each other and chill.

For several years I struggled with the language, but thanks to people like Mr. Locke and Mrs. Austin, I got more confident, and by junior year everyone knew me and I could talk easily to them. Girls thought my accent was cute, and they would come up to me and talk to me and ask, "Can you say this? Try to say it this way."

I believe more than anything, you need confidence. You've got

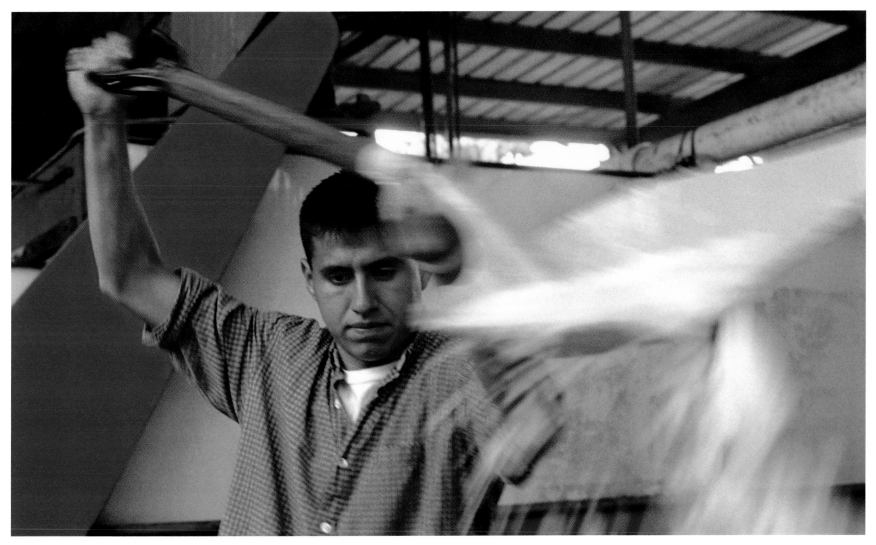

Eric Romero places ice on a layer of cleaned and prepared crates as they are stacked on pallets in the wash house.

Mexico now. I don't think I could do that. My parents have already made up their minds that we're not moving back. We're here to stay. My little sister, who's five, was born here, and for her it would be a lot harder. She would go through the changes that we went through when we came here. And my parents don't wish her to do that. She can understand most of the Spanish that we speak. She will say it right back to you. But she is primarily an English-speaker. She goes to North Canton kindergarten and does perfectly in school.

My younger brother is 16 now. He was in fourth grade when we arrived. His English is a lot better than mine. I don't even think he has an accent. His Spanish has kind of gone away. He doesn't work at Zellers and knows almost nobody from there. He hardly sees any Hispanic people. He's into football and plays for Hoover High School. He's more of a sporty person and does well in school. During the summers he takes care of our little sister, Gabby. She loves staying with my brother because he always gives her treats and candy. He knows how hard our parents work, so he does most of the housework and keeps the dishes clean. And he loves mowing the yard. He'll put his new Playstation portable headset on with his MP3s and drive around on the tractor. I wish I had more time to spend with my brother.

Basically, I'm trying to balance two cultures. I'm not trying to go for one and leave the other one behind. I'm not actually trying to live the American dream. I don't really think it exists. Sometimes people will say to me, "You've become Americanized now, and you think you're better than us." But I don't believe that. I don't want people to think that. That's why the number-one thing I try to do is to help others if they need it. There's always that one person, though, that tries to bring you down. But you can't let one person bring you down, 'cause there are three other ones that will help you. You have to be optimistic. I got this from my parents.

I know my parents have set the steps for me. They have influenced me in the way that they can. They taught me that you don't give up, you don't just say no. In the five years that I've been here, they've showed me you can come so far by working hard. And it doesn't have to be a fancy job. I'm trying to follow their steps and succeed. They want me to become a doctor and, basically, have a nice life. I'll try not to let them down.

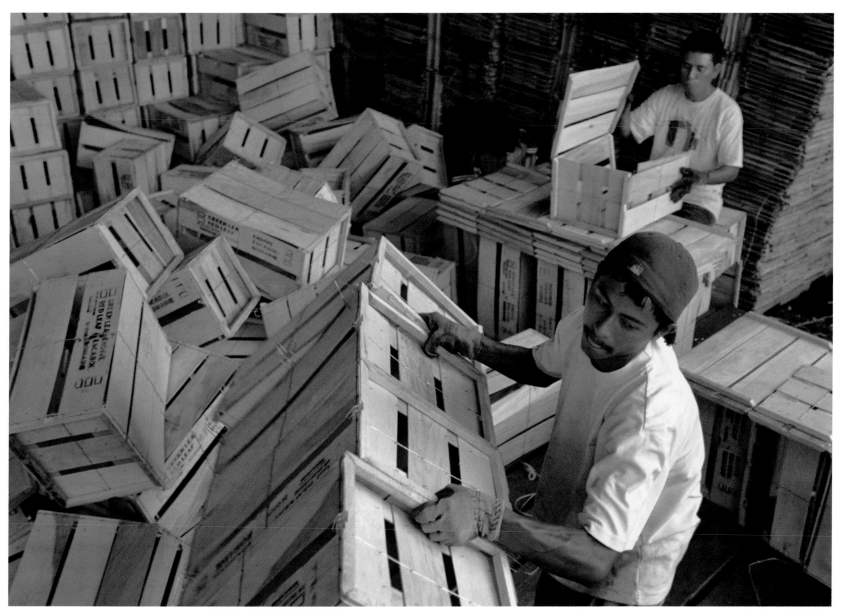

Workers assemble crates and secure them to the empty flatbed trucks after their completed delivery to the wash house. When the crates are secured, the driver will return to the fields for another harvest.

Mobile Education

For migrant children, the school year and the growing season are not at all in synch. When seasonal work is completed, the migrant families relocate, pulling their children from school at least twice each year. These interruptions in their education make learning difficult and can be a frustrating experience for many migrant children. Many of these children also struggle to learn the English language in addition to their regular school subjects.

The best-case scenario for migrant children is that educators will adjust to their needs and provide special tutoring and support. Teachers at the Marlboro Elementary and Marlington Middle and High Schools near Hartville integrate the children into established classes and offer tutoring sessions in order to provide more continuity in their education. At the high school level students are also provided with extra counseling and special study halls.

In the Hartville area, learning opportunities for these children abound. Through special state funding, migrant children can attend summer school while their parents work in the fields. Another opportunity, sponsored by the Hartville Migrant Ministries, is the children's summer program, which includes field trips to local sites. As part of their day trip schedule, the children and dedicated volunteers pile onto the Migrant Center's bus and head to destinations as various as a U.S. military museum in Canton or the Hartville Fire Department or a nearby roller rink. These excursions offer the children an opportunity to experience local life beyond the farm and field.

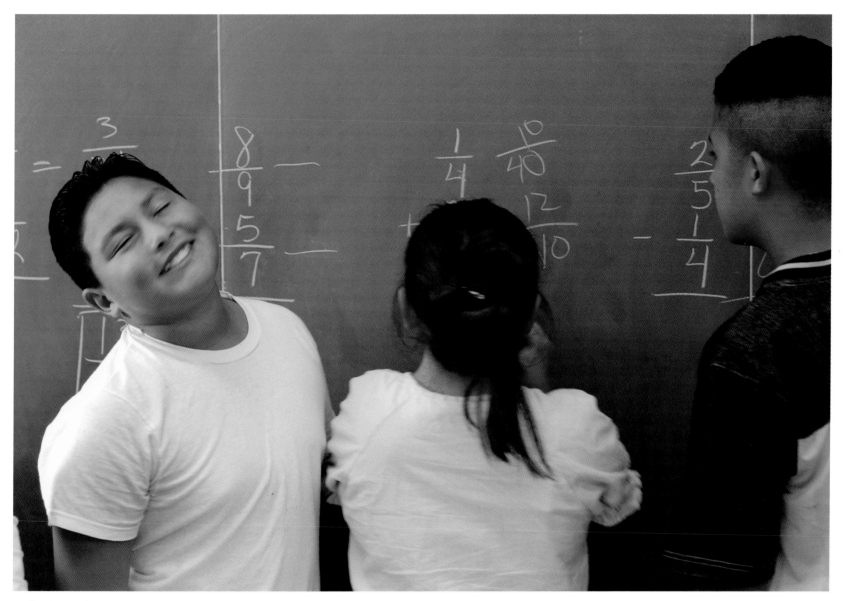

Jesús Páez works on math problems during a special summer session at Marlboro Elementary School near Alliance, Ohio. Migrant children are able to attend summer school because of special state funding. If it weren't for the funding, children would not have the educational opportunities that help bridge the gap between their migrant lifestyle and regular academic schedules.

María Consuelo López

My dad and I were the only ones in our family who wanted to come here. Even though I would have liked to have started my freshman year in high school with my friends in Texas, instead of thousands of miles away from home, I was willing to leave everything behind and just go for it. My younger sisters have been fed up with this place ever since the first time they looked at it. The only reason they can deal with it, I guess, is by knowing we'll be back in Brownsville, Texas, in six months. But I love Hartville. I'm always smiling in both places.

I remember my first fall at Marlington High School the students would come up to me and ask, "Do you speak Spanish?" Sometimes I would play around with them and pretend I could speak only a little bit, *un poquito*. It was fun watching their expressions. This one guy came up to me and said he thought I could speak Spanish because my name is María.

Every year I'd start my high school here then go back to Texas in October. Then around the middle of May, I'd leave school in Texas to come back here. The same group of friends was always waiting for me in both places. I would call my friends and write letters and tell them, "I miss you guys!" We would send postcards and pictures back and forth. Recently I had a couple friends visit me here, and they thought this town was like out of a movie. They asked me, "Are they paying these people to smile at you or what?" They loved it here.

I remember seeing Mexican movies about how people came over to the States illegally and worked in the fields and got mistreated, real-life cases that people tell and make into movies or books. So when I came here to Ohio and saw the fields, I felt this tremendous sadness come over me. I thought, I don't want them to treat my parents like that. That's the first thing that came to my mind, because I know that in some places they do that to people, they treat them like slaves. But I realized it was the total opposite here. Everybody was friendly and supported you and talked to you.

The summer I turned 16 I worked in the fields. I loved kneeling in the dirt. I loved picking out the radishes and onions, carrying the boxes and crates to the trucks. When it was pouring rain, we had to wear boots knee-high and work in the mud and everything. The other ladies were like, "Why are you here? You're just a little girl. Go home and play with your Barbies." But I said, "No, I love being here." I couldn't wait to turn 16 and start earning my own money.

Now I work at Head Start, which I like better than the fields because I'm helping children develop their minds. Everyday I tell them they need to learn things. I teach the little ones the alphabet, the names of colors, and how to spell their names. I like it when a child learns how to write his name and tells his parents, "Oh, Chelo taught me." That makes me feel good.

I guess the main thing that really pushes me to achieve all my goals and dreams is how hard I've seen my mother and grandmother work, how hard it's been for them. I know sometimes I don't show it, but I really appreciate all those things, all the hardships they've gone through to get me and my sisters ahead in life.

We don't close our doors at Head Start until the middle of October, until the last family leaves. We want to be sure that somebody's here to take care of the kids. Those last days, when the families start packing up and leaving, are kind of sad. Each night another house or trailer goes dark. One camp and then another closes down, until one night you're driving down Duquette and the whole street is dark and gloomy. But I still feel good because I know at the end of the season a kid learned the alphabet or learned how to write his name—and that's how I know I'm doing my job.

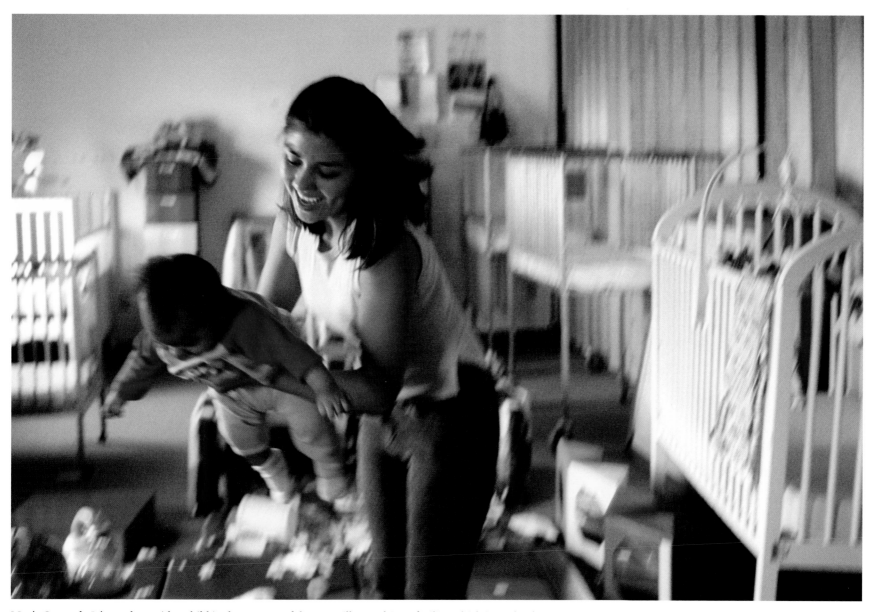

María Consuelo López plays with a child in the nursery of the Hartville Head Start facility, which is run by the Texas Migrant Head Start Program. María's parents are migrant workers, but she has left the fields to pursue other career options.

Cyndee Farrell

Years ago, I used to drive down to the farms to buy vegetables. In those days, there was a little roadside stand where you could go and get fresh produce. You'd see the migrants out working in the fields, all bundled up with hats and heavy clothing, wearing those big yellow rubber suits, and you'd think, what on earth?! Those poor people! That was the typical response: How do they do this, how do they live? Well, little did I know. I've come to realize that they are very happy people, living together in families with very tight bonds. They don't have such a bad life.

Near the end of last year, when the woman who was in charge of Marlboro Elementary School's migrant program had some health problems, I moved in as the director. We're a very small district, and we all have to wear many hats. So I'm both the principal of the school and the director of the migrant program.

During the regular school year, we have between 25 and 40 migrant children in our school, which is kindergarten through grade five. I also oversee the middle and high school students. Of the 340 elementary kids, the migrant students are definitely a minority and can easily be lost, if we let that happen. I don't think our year-round kids understand the migrant children's lives. They know they leave and come back, but, in between, they have no clue what goes on. It's rare that you see the kids or the families outside of the school, unless you go down to the camps for one reason or another, which I will do on school business.

As the leader of the school, I feel it's my own fault that I have not yet learned the Spanish language. It is something I really need to do. We use a lot of hand signals and body language to carry on, especially with the parents. During parent confer-

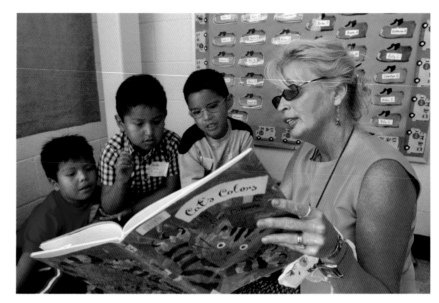

Marlboro Elementary School principal Cyndee Farrell reads to the children while their parents talk with the teacher during the first day of kindergarten.

ences, I often have an interpreter. But it's incredible how you can get to know one another without being able to speak the language.

We had one little boy who was having some problems at school and was taking things home. It was my first major venture into the camps. This child's teacher had told her friend, who was a policeman, and he went out to the camp and talked to the family. That was terrifying to those families, and it caused chaos. Everybody in the camp was ready to pack up and leave. I went out to the camp with the school resource officer to do what I do all day, which is triage. They were very shy and skeptical at first. They thought I was coming to follow up and that I must be on the side of the law. Fortunately, there were many English-speaking members of the family. We explained that this was not a police issue and apologized that the police had come. This was an issue

of helping their son grow up. This is one of the lessons we teach—not just reading and math and writing, but life lessons. This little boy had to find everything in his room and bring it all back and apologize. There were weeks and weeks afterward that he just showed up every day in my office and we talked. We really bonded over this incident.

It was my first real encounter with talking to the families in their own setting, on their own grounds, which is a safer place for them than here at school or, God forbid, the police department. My school resource officer still cautions me about going out on home visits; he just worries about my safety. But I feel safe in the camps. Most of the families I have met have an incredible bond. They work together, they play together, and they celebrate together. They may not have much, but maybe they've got what's most important. Maybe they've got it right.

I admire these kids. And despite their challenges, moving back and forth, dealing with two languages, they don't seem stressed. I don't think we give these kids enough credit. You might look at their score on a reading proficiency test, but when you consider what they deal with in the real world, they know a lot. That's not a test score.

We have a migrant tutor always on hand and an LEP (Limited English Proficiency) tutor that pulls out kids individually. As far as dealing with where to place them at the beginning of the school year, we're a little more lenient than they are in Texas. For instance, we've got a youngster who, if Texas has their way, will be in third grade for the third time because he hasn't passed the reading proficiency test. I actually had him scheduled to be tested for a learning disability last fall, but by the time we got the Spanish-speaking psychologist to come here, the family had already moved back to Texas. I sent all the paperwork to Texas, gave them the heads-up, and asked them to please follow through, but they just retained him and put him back in class. That is very frustrating for us.

My staff and I believe these kids are more than just their test scores. That's true with all our kids. But in this instance it's even more profound: the migrant students are dealing with two languages and two different cultures. We see growth, but in Texas it doesn't always seem to matter when it comes down to taking that one test. There are some good things about the testing, though. It can be an excellent diagnostic tool. And my teachers are very excited about the content standards. They really define what we teach and when. But all this emphasis on one test score takes the personal element out of our work, and that's really frustrating.

Sometimes the kids will show up in my office and say they have a bellyache, or they will come in from the playground and say they don't feel well. Often you can tell they are not really sick; they just

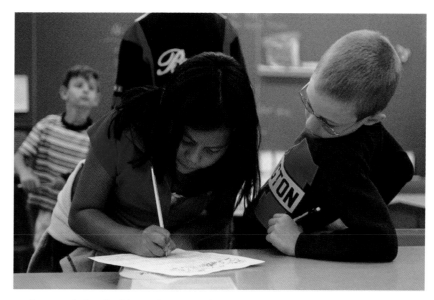

Atalya García is asked by a classmate if she went to a different school last year as children get to know each other during a get-acquainted exercise on the first day of school.

want to come down and hang around the office. We only have a part-time nurse, so I have a beanbag chair that I will pull into my office and let the child lie on it while I continue working at my desk. These are just children with big hearts. If my job didn't have this human factor, I wouldn't be here. That's what this is about.

But in the big picture I wish we could do more. I wish we had more funding. I would love to see more migrant aides that could be right in the classroom and stay with the kids all day. When you are Spanish-speaking and you only get 30 minutes with that LEP tutor, it is a bit of a Band-Aid.

My goal is to start a Spanish-language program in our building so the kids can converse. I think that would be a great way to bring them together. If we could have the migrant children act as peer tutors, put them in a situation where they are teaching the other children about their language and their culture, that could really open doors.

In the spring, when they come back, I'll walk down the hall with one of them to take them to their room, and the other kids in the class will yell, "Oh, you're back! Look who's back!" and they will all get excited. They really do welcome one another.

God forbid I get to the point where I am simply following guidelines. If that ever happens, then it's time for me to leave. My teachers are excellent and do what they must to help the students learn and pass the tests. But when I have to, as with the special-needs student from Texas, I am going to find a way to circumvent the bureaucracy and do what must be done to help the individual. It's a passion we all share at this school, and we'll continue to do what we can for all of our students.

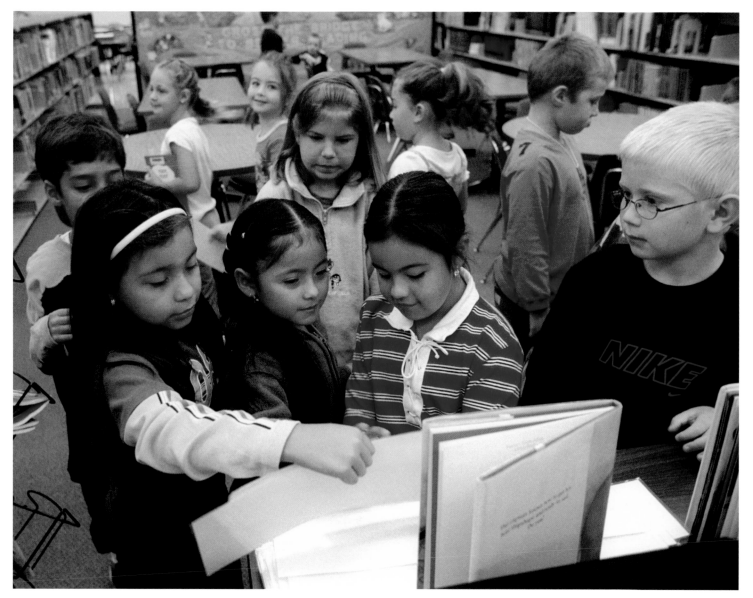

During fall classes at Marlboro Elementary, migrant children select books to read. Although the school chooses to split the children into different classrooms so they may grow from the experience, their choice is to remain together even within the individual classes.

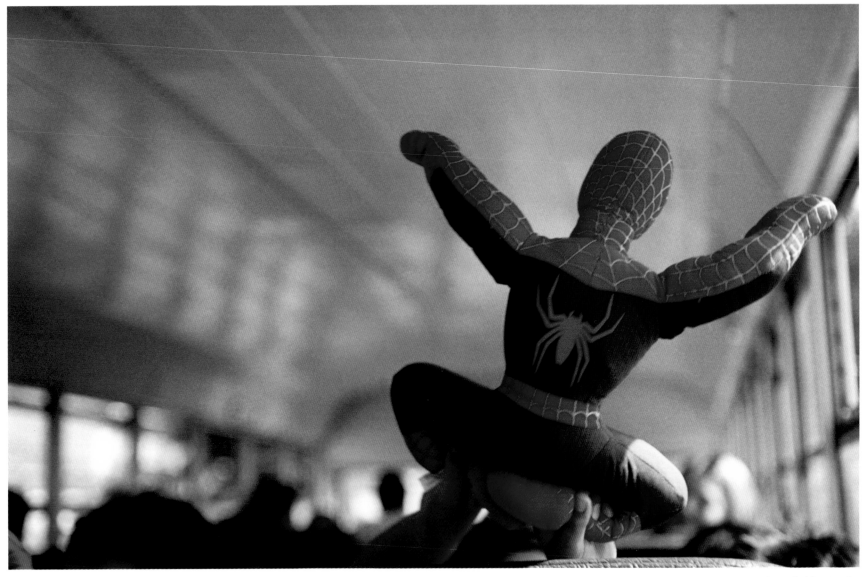

The influence of American pop culture is evident in the daily routine of the migrant children. During one day's field trip, the children played arcade games and won four Spiderman dolls. The toys fueled the imagination of the children during the bus ride home.

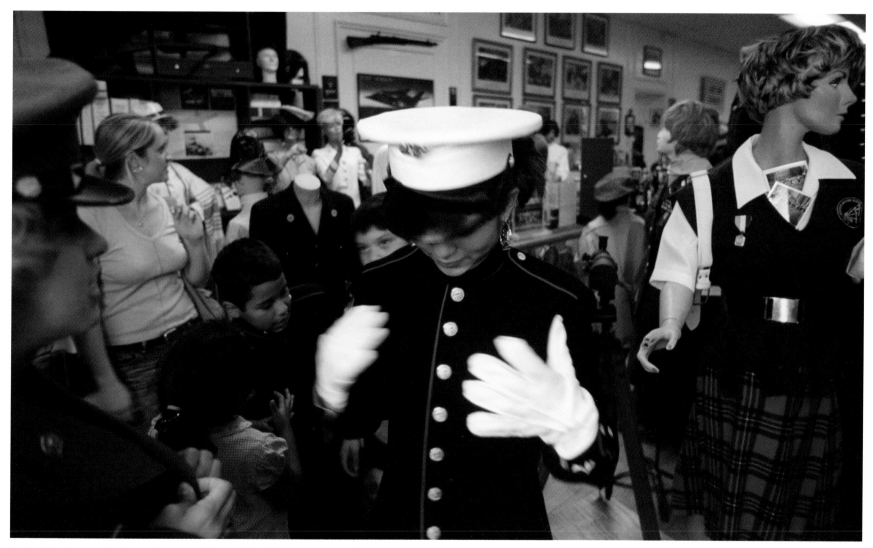

Carla Martínez and other migrant children visited the John Tsocheff Memorial Museum in Massillon, Ohio. While admiring the mannequins, the children removed the uniforms from mannequins and began playing an unusual form of dress-up. The curator was initially distressed over what was happening but then realized the educational experience they were having. He allowed them to continue and later took a picture of the children for his scrapbook. It took more than eight hours to reassemble the museum after the field trip, but the children have an open invitation to return any time.

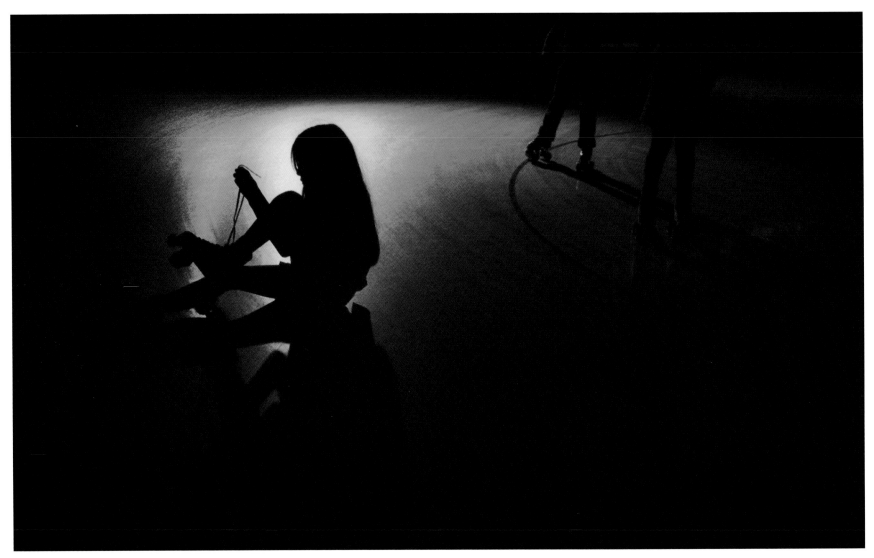

Amid the loud music and swirling colored lights of a roller-skating rink, a girl stops in the middle of the floor to tie her skate while two other children hold hands and attempt to keep their balance. After spending the morning in summer school, the children took part in this afternoon trip.

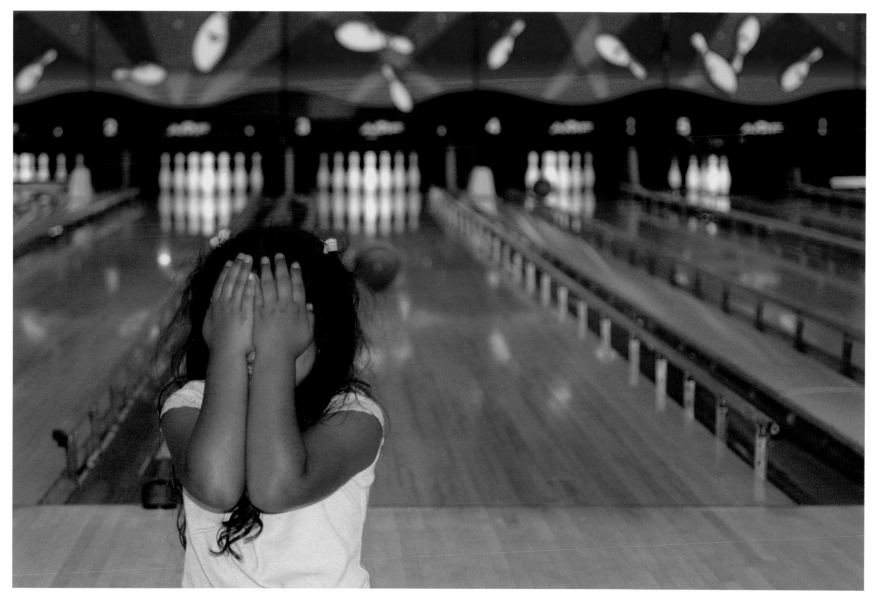

Yuliza Félix covers her face after releasing the ball during a bowling trip in Canton. The Hartville Migrant Center Children's Program offers many trips that are educational, while others are purely for fun. The host venues do their part to support the program by offering special rates and times.

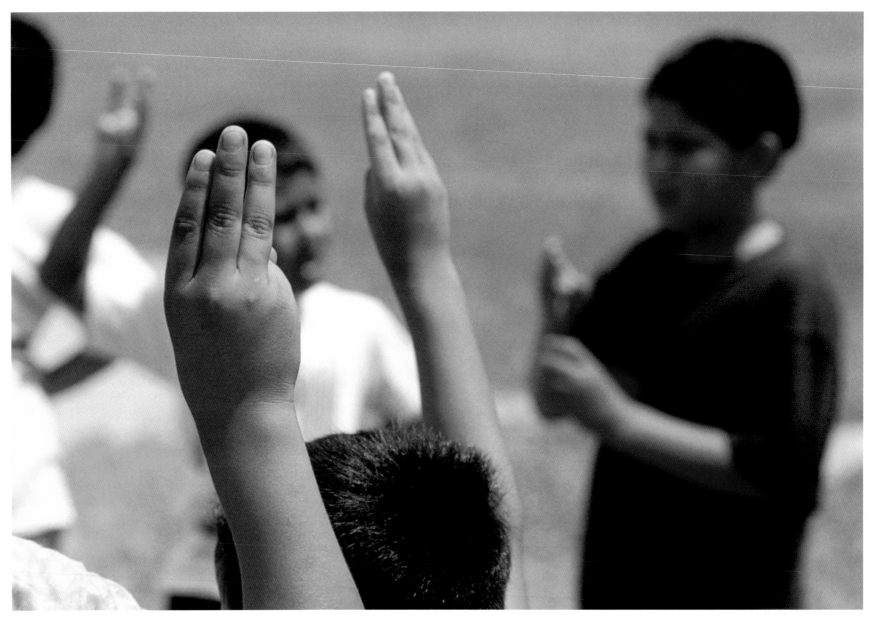

Migrant children practice the Boy Scout oath while participating in a field trip at a local park.

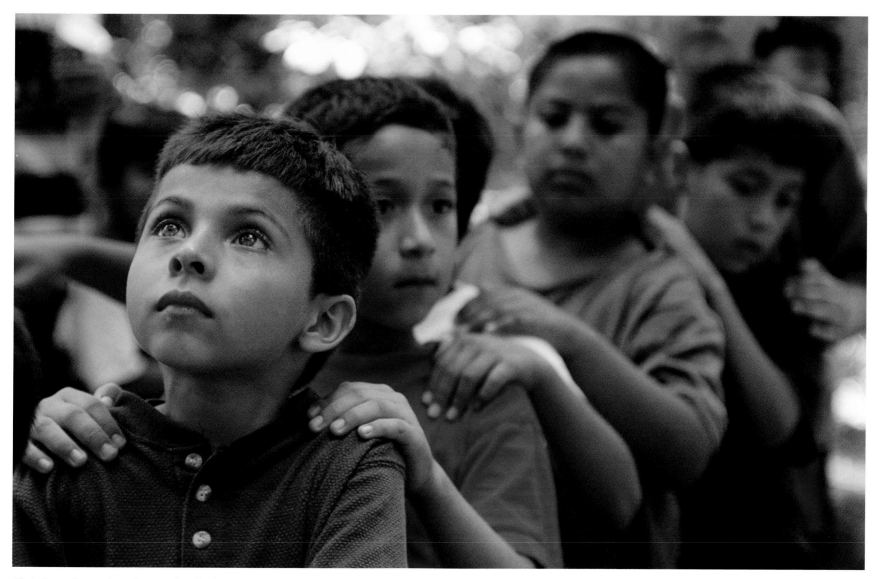

Christian Vela, José Medina, and Erik Flores participate in a team-building exercise during a field trip.

Pat Moore

When I heard that they were asking for volunteers at the Migrant Center to ride the bus for the children's field trips, I went down and put my name on the list. This was about five years ago, around 2000. At that time, Larry Deiner was the head of the summer programs. He was at my granddaughter's Christian school, so I kind of knew of him.

I remember my first day on the job we went to Silver Park in Alliance. There was a huge hill that the kids could run up to reach a plateau at the top. I was in charge of two boys who were about seven or eight years old, and my job as a volunteer was to keep an eye on them. Well, the first thing they did when they got off the bus was run up that hill and out of sight. There was no way I could run up after them. So this one little hot-shot boy, Edgar, turned to me and said, "Hey Pat, you got problems." I said, "What?" He said, "First day on the job, and you already lost two kids. This is not a good sign, this is not good."

But Larry had total command of those kids. Of course, he could speak Spanish, too. I remember at the railroad crossings he would never shout. He would just say very calmly, almost with an English accent, "Children, now we must be quiet. This is a railroad crossing. Please, no talking." He wouldn't go until they were totally quiet, and as soon as we crossed over the tracks, they would scream and holler and let loose, and that was fine. Every now and then he would take the bus down a road where there were sprinklers in the field with their spray crossing into the street. He would never warn the children to close their windows, and they would always get a mouthful of water. They would scream and holler and chant, "Larry, Larry." He had a great sense of humor. Every once in a while he would say

something like, "Well, thank you, Alberto. That makes my heart very happy." The kids would just love that. All the kids had a great respect for Larry. They called the bus "the Larry Bus."

The first year I met the Soto family I was so impressed. Georgina was about nine at the time, and Brianna was only two or three. Their brother Marco was probably 11 and Beto 13. I was impressed with the fact that when Brianna needed to be babysat, the other kids would take turns staying at home to watch her. And no matter what activities we were doing—going to Six Flags amusement park or golfing or bowling—there was never any whining. Our bus would drive by the Soto house and everybody would wave at Marco or Georgina on the porch with Brianna, and they would just wave back in the best spirit. That's when I began to recognize that this was a very special family. They were all unspoiled, very responsible, just joyful people.

That summer we had our first Fourth of July party with Larry Deiner and his wife and children and the whole Soto family. My husband, Jerry, took Marco and Beto downstairs with Jerry's paint set, and they painted a Mexican flag so they wouldn't feel left out. We tacked it to the tree down in the picnic area. They got the biggest kick out of that. Every Fourth of July since they have come over, and we put chairs out front and watch the Congress Lake fireworks. We have cake and ice cream, and the boys play soccer down in the field.

Congress Lake Country Club is kind of an uppity place. President McKinley slept there and that kind of thing. We belong to it to play golf, and I've taken some of the migrant children to the country club to swim in the pool there. The first time we went some of the members remarked, "Who are these kids?" They were darker skinned and looked different. But many of the members were impressed by how well behaved they were and what nice kids they were. Apparently nobody knew that there was a migrant center just a mile down the road. I'm not sure how this happened, but somebody at Congress Lake Country Club got connected with the Center and raised money for the ministry. I was shocked. I think it kind of evolved from the kids swimming over there. The members saw the children and the word got out. I think people are always looking for a way to help other people, if there is a personal and trustworthy connection.

I wasn't raised with a silver spoon in my mouth, so I've never had that mentality. And I think the children see that in me right away. I think that's why they are so comfortable with me. My grandkids are all grown, and they are going their separate ways. The youngest one is now 17 or 18. So I'm enjoying these children. It's been one of the highlights for me these last four years, an absolute joy when they come back.

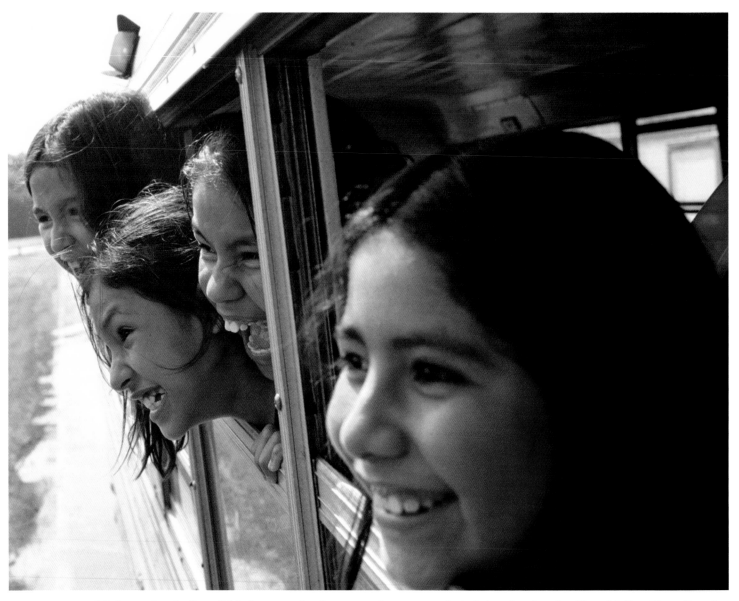

While passing the farm field after returning from an outing on a particularly hot day, Jasmine Mata, Melissa Mata, Georgina Soto, and María Delgado wait with anticipation to be sprayed by irrigation water. The bus driver noticed that the hose had been placed close to the road, and she pulled over so that the children could enjoy a cool spray.

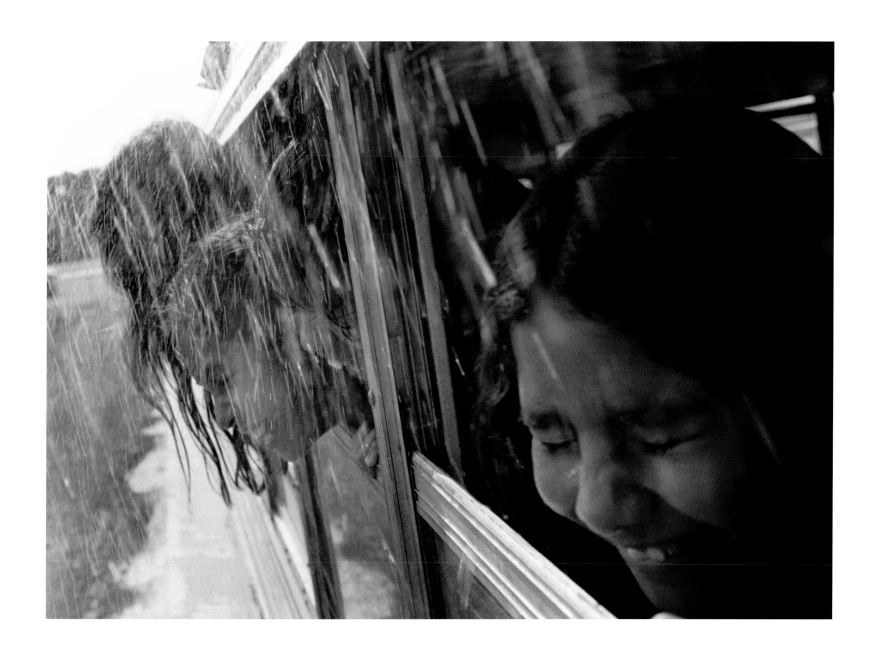

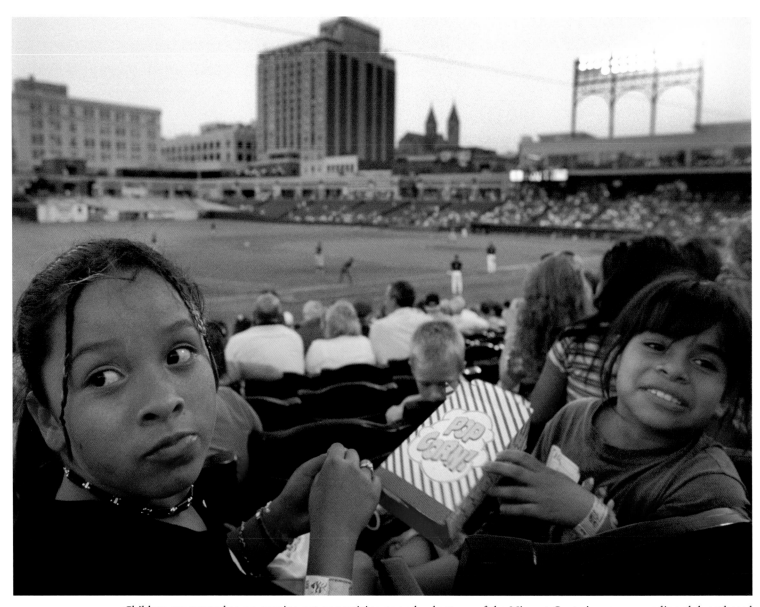

Children are treated to an evening out as participants and volunteers of the Migrant Center's summer reading club gathered for a trip to an Akron Aeros baseball game. The outing was an opportunity to celebrate the opening of the Center's bilingual library.

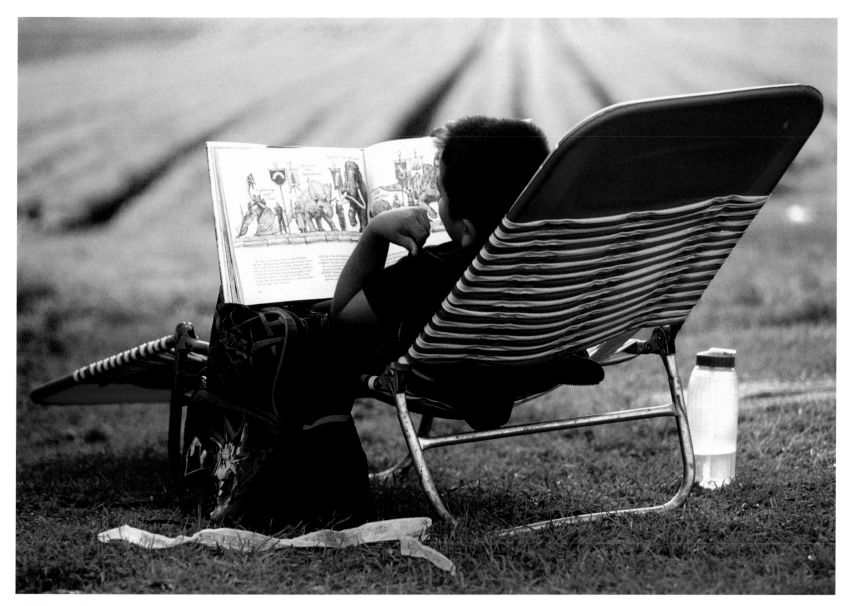

With his book bag, donated through the Hartville Migrant Ministries, and a bottle of water at his side, Diego Rodríguez finds a quiet place to settle in for stories about the mysterious world of dinosaurs. With a view of the fields, he waits for his parents to return from their day's work.

Migrant Center

The Hartville Migrant Center sponsors many vital activities in the migrant community and serves as a shopping center, medical facility, school, and religious gathering place. As the brightly colored mural on its side wall illustrates, the Center is a source of support for this migrant community and for others who work at area farms. The Center has a long history of service. In fact, the first migrants in the United States treated under the Migrant Health Act of 1962 were migrants in Hartville. Some of the volunteers at the center have been actively involved for nearly 30 years.

The Hartville Migrant Council oversees the operation of the Center. While the snow is still on the fields, the council begins to set the summer schedule of programs for children and adults. Though the Center is closed during the early part of the growing season, members of the Hartville community are hard at work preparing to open its doors in mid-April. A group of volunteers from a local church meet to create handmade quilts to include in welcome bags that are given to the returning workers and families. Book bags for the children are gathered and filled with school supplies. A host of churches, organizations, schools, and concerned citizens donate food items, personal products, kitchen utensils, and clothing to be sold at discount prices at the Monday-night thrift sale in the Center.

The Center's primary role revolves around health services, educational programs, and administrative support in dealing with all the paperwork associated with a transitory lifestyle. Hartville's is one of the few centers in America that offers in-house services such as these.

Since many of the same workers return each year, the Center keeps a medical file and history for each worker. Volunteer medical support and personnel are gathered from a variety of sources. Kent State University, Northeastern Ohio Universities College of Medicine (NEOUCOM), and Malone College contribute medical support while at the same time provide educational opportunities for their students. Aultman Hospital provides the services of a doctor for one day each week along with family medicine residents in training. Kent State University also offers graduate student interpreters as an essential component of the Center's medical care. The North Canton Medical Foundation offers medical services such as pediatrics, family practice, internal medicine, and specialized care that includes free labs, radiological services, and medical testing. The Stark County Health Department provides immunizations and well-child visits.

The Center also offers ESL/GED programs, education opportunities, Bible studies, legal assistance, and outreach services for adults, and children can enjoy a bilingual library and attend a weekly story hour. In addition, a self-tutorial, computer-based instruction program, Nova Net, is available to those who wish to receive high school credit or to earn their diploma.

When Memorial Day weekend arrives, the Center becomes fully functional and is a model of volunteerism and community service. The Center is open six days a week, offering programs and services often late into the evening. The area growers have come to rely on these services that help provide a better life for their workers.

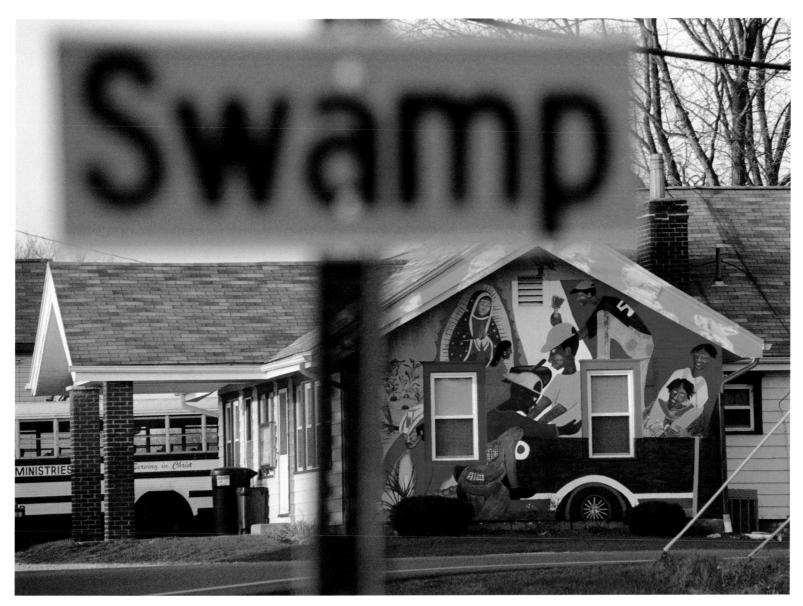

The mural, created by Héctor Castellanos Lara and painted with the help of members of the migrant community, adorns the side of the Hartville Migrant Center at the intersection of Swamp and Duquette roads. The Center is home to the Hartville Migrant Ministries.

Penny Griffin

It was the black muck soil that really captured my interest when I first started working in the fields. I remember how dirty I used to be when I came home at night. And when you were sweating and the breeze blew, the soil stuck to you. It felt like stepping out of the shower and having somebody throw a bag of flour on you—only it's black instead of white. You'd go home and wash your hands with Clorox and your fingernails still looked dirty, even though they were clean.

But it's a healthy environment here. I wouldn't want to be anywhere else. It's a whole different world from the suburbs where I grew up. In the suburbs you don't have to know your neighbor. But out here that's not the way it is. Everyone relies on one another in the camps. And I feel that I have become an integral part of their family.

As the director of the Migrant Center, I work on a daily basis with the migrants, usually from the middle of April to about the end of October. They all know that I started out actually working in the fields, so I know what their job is and what their needs are. Besides being business buddies, these people are my friends.

Often when I go to one of their houses to deliver a message, I can't leave without eating something. They want me to sit down and eat. "¡Siéntese! ¡Siéntese! Please sit down!" Most of them consider me undernourished. And I'm far from being undernour-ished. But when I'm at the Center, I don't take time to eat. I can make a cup of coffee for myself at nine o'clock in the morning, and at two o'clock in the afternoon I'm still sippin' on the same coffee. It's colder and has been rewarmed in the microwave a dozen times. It's just that it's nonstop from the time I open the door to the time I close the door. It's grab-it-while-you-can. I don't really have time to sit down and enjoy a coffee break. The migrants think that's awful. They come in here and put a plate of tacos or tortillas in front of me and tell me to eat. I may have 10 people in here trying to see a doctor, and I'm trying to pull files, yet they'll sit down in front of my desk, as if I'm going to eat it right now. I've learned that if they offer you something to eat and you refuse the food, you actually hurt their feelings, so I always tell them I'll have it later.

There are families that come back here year after year. They are very deeply rooted here. That has to say something about this area. That has to say something about the owners of the farms. The growers take great pride not only in their farms but in the migrant population and in keeping up their housing and working conditions.

It's a great place to be and it's got its rewards, though they're not necessarily in the sign of a dollar bill. The rewards are in a smile, a hug, a kiss on a cheek, a thank-you. You might be driving down the road and they'll wave at you, or they'll come to your house to say hello or to tell you good-bye. Those are my rewards. They're not what many people expect from their job. But you can't put a price on my rewards.

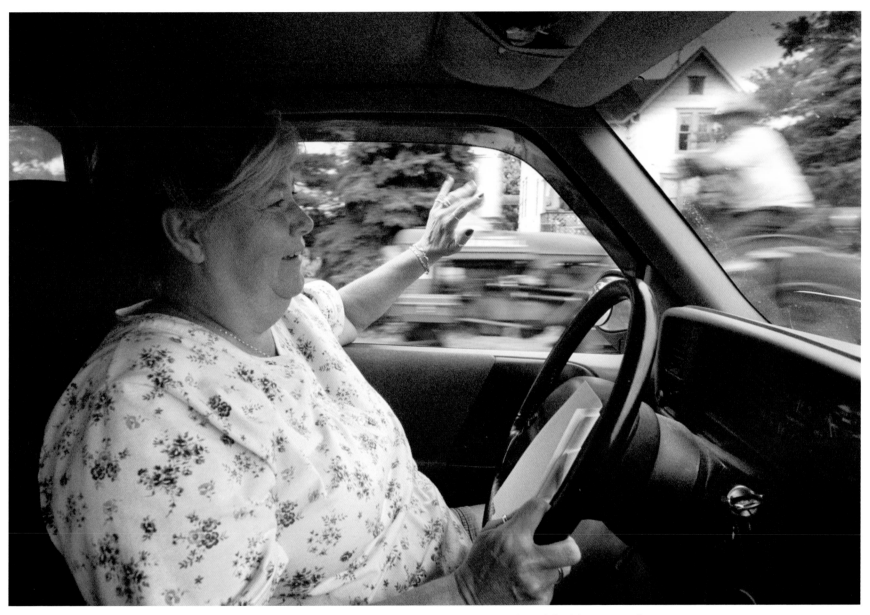

Penny Griffin, director of services and office manager for the Hartville Migrant Center, greets a worker while delivering mail to families on Swamp Road.

Penny Cukr

When I came to Kent State University in the early 1990s to teach in the School of Nursing, I thought, what could I do? I had worked in a community nurse practitioner program at Rush University in Chicago for 13 years and had consulted with a large Spanish population there, many of whom didn't have integrated care. It didn't take a rocket scientist to figure out that these gaps in health care exist throughout the country, and I believed the need was here in Ohio.

I have an aunt who lives in Hartville, so I asked her to drive me around. I saw this little clapboard house that apparently was the Migrant Center. There's a big beautiful mural on one of its walls now. But at the time, it looked like nothing in particular. I had to wonder what was going on in there. I contacted Tom Montgomery, who was in charge of the Migrant Center then, and I created a small proposal to put Kent State nurse practitioners with students out there in the health clinic.

That first year we publicized our services by putting little signs up in the bathrooms and on everyone's doors, listing our hours and how they could get in touch with us. I had the illusion that we would get a lot of appointments, but it just didn't happen that way. People would not make appointments, and we had to accept that. They came at their convenience, often with others to socialize. I didn't think about the fact that if they missed work for an appointment, they wouldn't get paid. So they came at lunch. And if they had sick kids, they came early in the morning before work.

That first year I wrote a grant to CARHEN (Canton Area Regional Health Education Network) and received a generous amount of money for the next five years to purchase tables, otoscopes, ophthalmoscopes, scales—the kinds of things you need in a primary-care office. We got tremendous support from Kent State University and the Migrant Council. It was teamwork from the beginning with many folks volunteering.

Now we have a well-developed clinic with a population of about 350–400 people who come in for regular care during the growing season. Our faculty is very dedicated. I love to tell this story: Two years ago, our male nurse practitioner, Scott Fleming, fell off scaffolding and broke both his arms. He has been one of our major contributors to providing care out there. For a while he had pins in both his arms, but he still insisted on coming out to the clinic. In fact, he would drive himself out. I was there one day when he got out of his car, and I said, "Scott, you're crazy! If the cops ever see you driving with two broken arms, you're going to be in trouble." And he said, "But I have to take care of these folks. I have to get out here!" I'm proud of the fact that our program also enriches our students, who are basically white, Anglo-Saxon Americans who have had little exposure to other cultures. We hope our students will experience some broadening in their attitudes about how they look at folks whose lives are very different from their own. And the best way for this to happen is to get to know the people, not just read an article or passively observe someone.

In the beginning it was just nurse practitioners and students from Kent State. But it has grown on its own and been accepted and embraced by so many organizations in the community. Now I see myself as one of the least important people in this whole operation. We have great partnerships with North Canton Medical Foundation and Aultman Hospital, with Northeastern Ohio Universities College of Medicine, Malone College, and the University of Akron. We encourage any university in the area that wishes to have their people involved to come out to the Migrant Center. I always thought if I could make a small army of nurses and students, people who are committed to working to reduce the disparities in care and the gaps in our health-care system, then I could do a hundred times more than I could on my own.

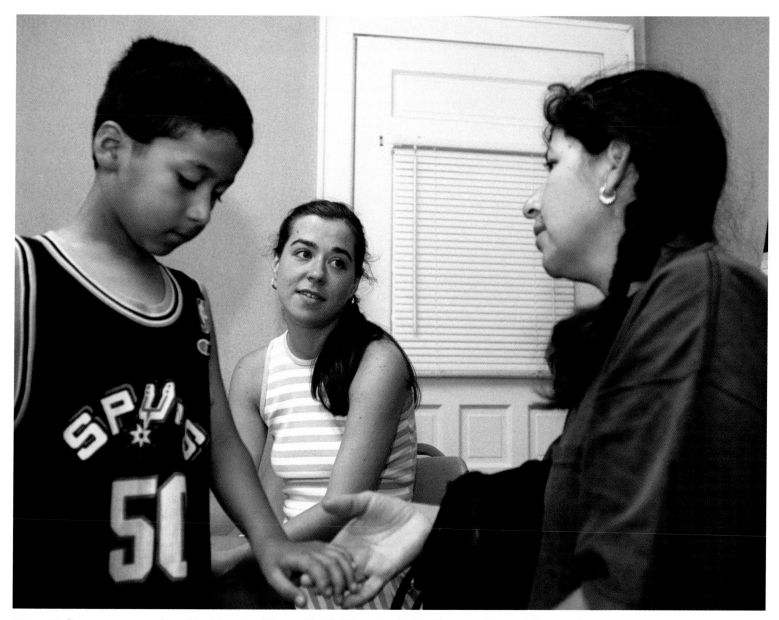

Nester Medina was nervous about his visit to the Migrant Health Clinic. Jessica Buckley, a student studying translation at Kent State, helps explain the doctor's advice to Nester and his mother, Éster María Medina.

Dr. Teresa Wurst

The migrants call me *La Doctora.* That's the name for a female doctor. Instead of calling me Dr. Wurst, they just say *Doctora,* because I used to be the only female physician who came out to the Migrant Center. They all knew who they were talking about.

Aultman Hospital frees up my schedule so I'm not missing a day's work to come out here. It used to be I was only out here for two or three hours on Thursdays, but it has evolved into an all-day thing. I practice family medicine and teach NEOUCOM medical students and Aultman Family Practice residents about community medicine at the clinic.

When I started in 2002, I thought I would just show up and see patients, that there would be a schedule and everything would be organized and set up. I found out that was not the case. I thought I could use my high school Spanish. But I got here and realized I had forgotten just about everything I had learned. And what you learn in high school is not really practical. I soon got books and tapes and CDs to help me learn. So every day I've got something in the car with Spanish. I can get through a patient interview now on my own, but I couldn't even begin one when I started.

I still have interpreters at the clinic as much as possible, because you can miss a word or two, and you might miss the boat on what the patient is there for. I had a young girl who was pregnant come in with her mother. I didn't know where her parents worked in the area. She was 14 or 15 years old and had been raped. But I didn't know the word for rape. I thought, well, she probably has a boyfriend or whatever. I didn't really understand what she was saying. Fortunately, I had an interpreter

that day. She knew what was really going on and explained it to me. The rape happened in Mexico, so we really couldn't do anything to prosecute the rapist. I asked what the Mexican police would do, and they said the police would do nothing. I was appalled. We talked about what she wanted to do with the pregnancy, what her options were, and I got ahold of the Rape Crisis Center. We were able to find someone who spoke Spanish who could counsel her, and we set up an appointment. It made me realize how important it is to always have an interpreter.

When I first started here, I was concerned that nobody was being tested for tuberculosis. Most of the migrant workers come from a very high-risk population for TB. I said we really need to do this, and the growers agreed. They basically told the workers that they had to be tested in order to work here. So Dr. Laura Wyss, a nursing instructor from Malone College, wrote a grant to cover our costs for the testing. Our first year we had somewhere between 50 and 60 positive cases of latent TB. This meant they were exposed in the past to someone with active tuberculosis, but they weren't active cases. They all still needed treatment to prevent reactivation of the dormant TB. Laura literally went out into the fields, knocked on doors, woke people up, and said, "Hey, let's get your TB test." Every year now it gets smaller and smaller. Last year there were probably only about 20 cases, not a lot. But that first year it was like an epidemic.

Initially, I only saw women and children. There were no men coming to the clinic. I thought, that's interesting, because I'm sure there are a lot of men out there. But culturally, to see a female doctor was a problem, as it is for some people even in this country. Perhaps they thought I didn't know as much. I don't know what the issue was, but I wasn't one of them, and I didn't speak very good Spanish. But after I took care

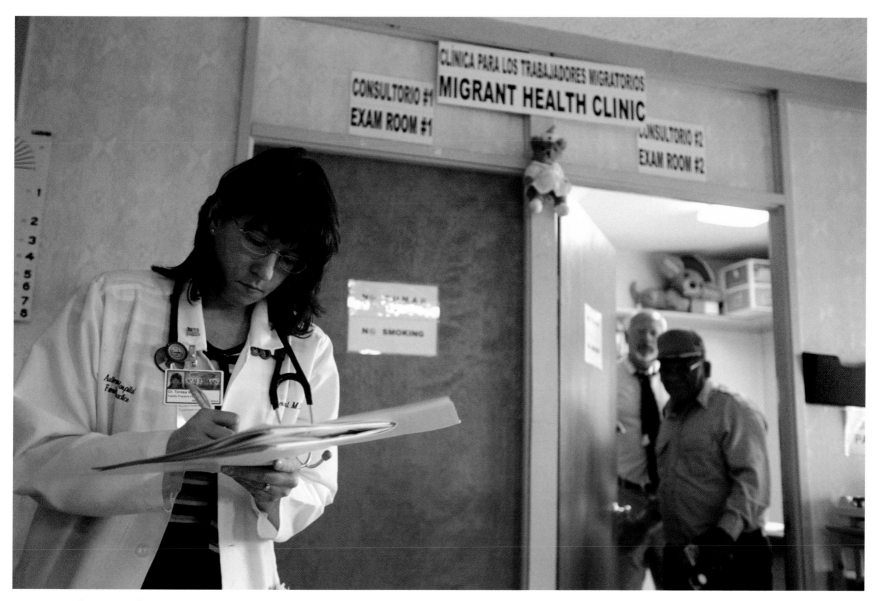

CONSULTORIO #1
EXAM ROOM #1

CLINICA PARA LOS TRABAJADORES MIGRATORIOS
MIGRANT HEALTH CLINIC

CONSULTORIO #2
EXAM ROOM #2

NO SMOKING

Dr. Wurst makes notes after seeing a patient at the clinic.

of their wives and their children for a year, I think they thought, well, maybe she's okay, and slowly they started to trickle in. Yet it wasn't until we did the mass TB screening that I really got to know the men. Once I sat down and talked with them and gave them information and free medicine, they started to trust me a little more.

We also started a free condom campaign. I piled up condoms in baskets and put signs up. They had to find some reason to come in to get the condoms. That's a very common form of birth control. One day I was seeing a little boy for an ear infection. I was looking in the kid's ears, and his dad was very slowly stuffing his pockets with condoms. I was trying hard to not appear like I was looking. The kid really wasn't that sick. Then I heard the little boy ask his father, "What are you doing daddy? What are those?" "Oh, nothing," his father said. We keep the free condoms in baskets in the exam room, so the men have to come in and see the doctor to get them. The condoms bring them in.

I never give out my home phone number in my private practice, but I do on occasion with these migrants, because they really don't have anywhere else to call if there is an emergency. It's always funny, because often when I get a call at nine or ten o'clock on a Sunday night, my husband will hold out the phone and say, "There's someone speaking Spanish on the phone."

I once got a call on a Sunday night, and it was the cousin of a patient I had been seeing, a single man about 19 or 20 years old who had recently had an infected cyst removed from his lung at Aultman Hospital. It was a serious operation that saved his life. Apparently, he was really short of breath and was in a lot of pain and coughing up a lot. I told his cousin to call an ambulance or take him to the emergency room. But he didn't want to do that, and I couldn't convince him. It was about 9:30 at night, and he asked me if I would come out. I know going out somewhere at 10 o'clock at night as a woman to a rural, deserted clinic on Swamp Road is probably not the smartest thing to do, but I feel safe with these people. I knew this was going to be okay and there would be other people there. So I drove out to the clinic and said, "Where is he?" "He's too weak to come," his cousin said. "You gotta come to the house." So we loaded up my car with some blood pressure cuffs, an oxygen monitor, and other equipment, and I drove out to his camp.

When I arrived he was sitting up in his bed in his one small room. There were religious candles lit all around him, and everybody was standing by his bed. He looked to be in a lot of pain. It sounded like there was a lot of fluid in his lungs. But it was difficult to know how serious it was without an x-ray. I checked his vital signs and said we really need to call an ambulance. Only then, with me there, was it okay for them to call an ambulance. It was a matter of trust. So the ambulance came and pretty soon there was a large crowd gathered outside his house. I called ahead to the hospital just to make sure there was someone in the emergency room who could speak Spanish. It turned out he was not ill enough to need readmission to the hospital and went back home after being treated in the emergency room.

I love that we're able to make a difference to a community that doesn't have a lot of help. My faith is a strong force in my life. It's a big thing for me to work where I can make a difference, where I can use the gifts that God has given me to help people with little or no access to health care. I try to remember what Jesus said: "When you did it for one of the least of My brothers, you did it for Me." These migrants are a very hard-working group of people. They want to work, even when they are sick. And when something happens to somebody, everyone pitches in and tries to help.

One of the things that really strikes me about these people is that despite the situation they are in—working long hours in a miserable

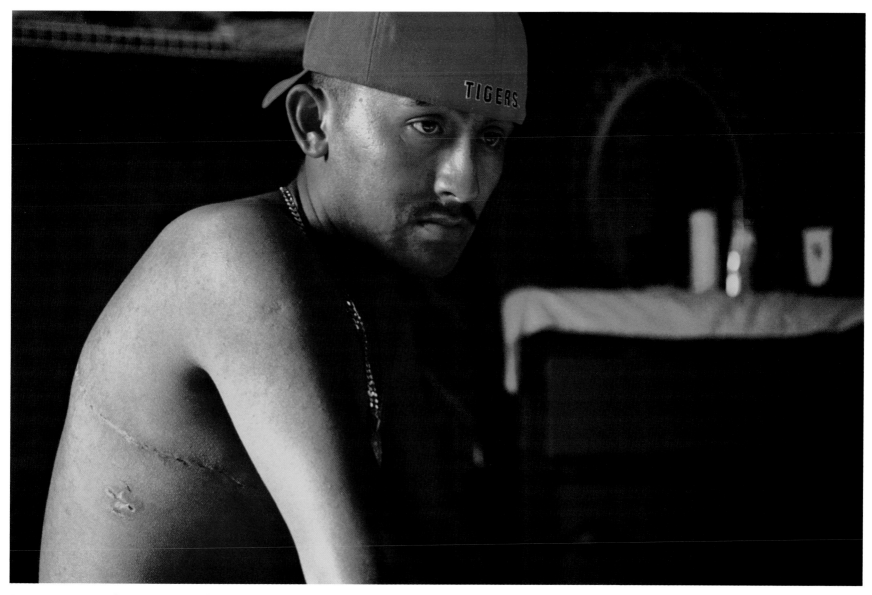

Surgery was required to remove part of Alfonso Meléndez's lung. Dr. Teresa Wurst and other physicians from Aultman Hospital detected the problem and helped him throughout the surgery and during his recovery. He believes Dr. Wurst saved his life.

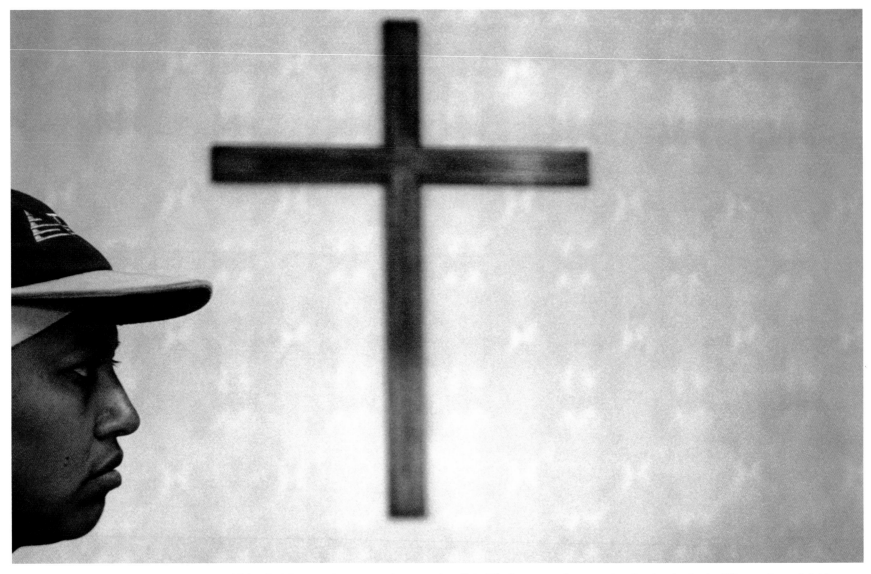

Alejandra Flores waits to see a doctor at the clinic. The large wooden cross is a focal point in the Migrant Center's lobby.

hot rubber suit, kneeling in muck—they're very happy people. It's re-freshing to see a group of people that are happy with what they have and are thankful because they have their family and can provide for them.

Birthdays are always a big deal, a reason to celebrate. I've been to quite a few now, and they're always fun, usually with 50 or 60 family members and friends. I wish I could take some of my patients who complain about every little thing out to the camps and the Migrant Center and say, "Look, appreciate what you have."

Coming out here is always the best part of my week. I always get excited in April before the growing season starts. We have meetings and order supplies, and I go out to the clinic to clean. I take my scrub bucket and Lysol and scrub all the rooms down to wash away the black dirt that has settled on everything. I get my nine-year-old son, Nicholas, to come out with me, and he helps me clean.

Every year the migrants come back and ask, "So, did you learn some more Spanish this year?" They like to joke with me. You know you've been accepted when they start inviting you to their birthday parties, and they all want *La Doctora* to hit the piñata.

A worker is brought from the field and tested for tuberculosis. Because of the community health issues associated with TB, all workers are tested and treated when necessary.

stopped working on the walls, and I brought out food and candles. We sat down for awhile and then went back to work. On Memorial Day we had our open house, and we invited our friends and family to come and see what we had all accomplished. We had turned it from a drab and dingy place into one that says, "Welcome! We're happy that we're here to work with you."

Of course, when I first checked the box "migrant worker," I had no idea what I was getting into. I had no idea that I would serve as president of the Migrant Council for six years and still be a member of the Council today. I just believe in what I do and am willing to work as hard as the next person.

I'm sort of split, because I love to organize but I also love to be the one working with the people. The Monday-night thrift sales are so energizing for me. I love to be able to talk with the adults and the children, and I love to hold the babies. I didn't realize that I was getting a reputation—not a bad reputation, but everybody knows on Monday nights Señora Sandy gets to hold the babies. If a baby comes through the door, Sandy is going to get it. Monday nights have become like a family.

Last year at the sale, as part of our Operation Book Bag project, we handed out book bags to every child. There was this one little girl, Rosa, who got her little Strawberry Shortcake book bag and just held on to it all night. She ran up to each adult in line and showed it to them. Later she sat down in the center of the room with the other children, like someone wearing a brand new dress, and wouldn't take off her bag for the rest of the evening. It was such a rewarding feeling to see that. I know I'm hooked on the Monday-night thrift sales.

I believe this is a place where, when you enter, it doesn't matter if you are Hispanic or African American or if you live in Congress Lake or wherever. Here, we are all just people. We all have the same basic needs. And we're not judging anyone because they're coming to the sale. I may be the one who needs the helping hand tomorrow, and I do firmly believe if you have helped, it's going to come back and you'll be helped.

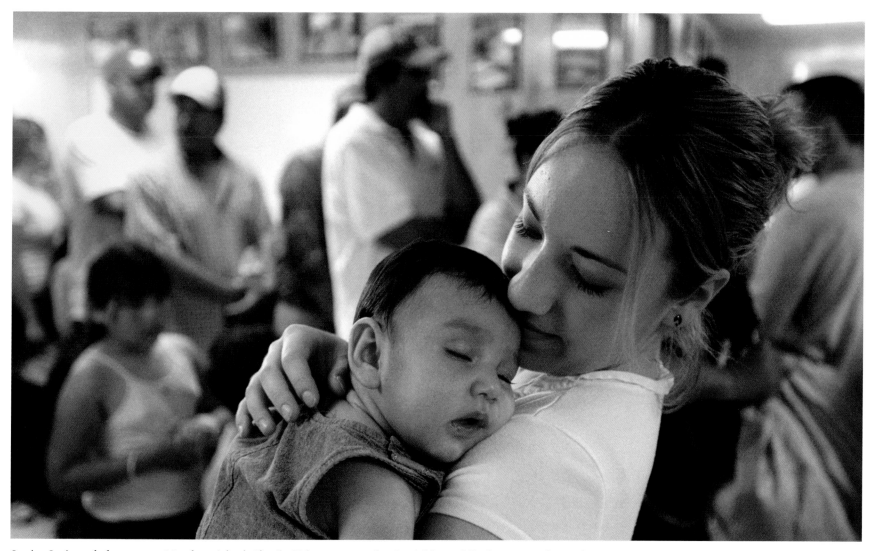

Jessica Springer helps out at a Monday-night thrift sale. Volunteers care for the children while the parents shop. Edwin Pantoia is able to sleep in Jessica's arms despite the hustle and bustle of the thrift sale.

Camps

The growers, K. W. Zellers and Son, provide housing for their workers on the perimeter of their 500-acre farm. The housing is clustered into seven "camps." The workers are assigned housing based on seniority and the number of people in a family. Named after the former owners of the property on which they stand, each camp has a distinctive appearance based on function and the lay of the land. Warner Camp, for example, offers homes that are connected in a long row, similar to apartments, while Royer Camp is a collection of mobile homes grouped along an oval drive. Between the camps are individual houses—mostly old farmhouses that have been fixtures of the countryside for decades—that are available for the most senior of the returning workers and their families. To accommodate a changing workforce, some of the housing can be adjusted from single-room to multiroom facilities by removing a privacy door placed between the spaces.

Most of the housing in the camps does not have individual bathrooms or telephones. Yet in the center of each camp are community bathrooms, shower facilities, pay phones, outdoor laundry areas, and clotheslines. Some of the camps also have play areas for the children, whose brightly colored toys give the "neighborhood" a familiar, homey feel. Although it is meant to be temporary housing, it is common to see potted plants, small gardens, and decorative items near each home. For many of the workers, this is their northern home, and they want it to feel more like a home than a camp.

Because the workforce is so tightly knit, there is ongoing communication among the camps. Any noteworthy occurrence becomes well-known by the entire community within a few short hours. There is plenty of opportunity to make plans to socialize, host cookouts and parties, and share special family events. What was meant to be temporary housing for seasonal workers becomes for many, quite literally, a home away from home.

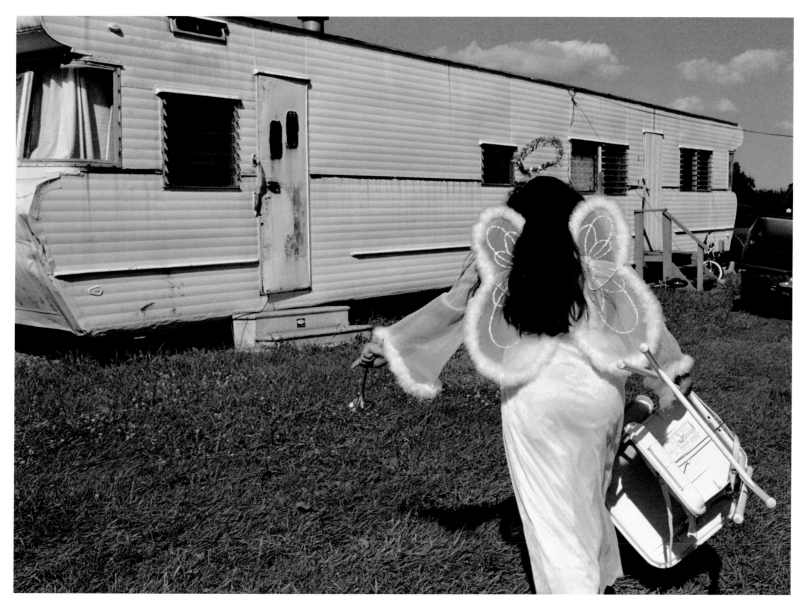

After a passerby brings a variety of household items to the migrants in Royer Camp, a child breaks from a costume party to take a chair to her home. Occasionally, and often without notice, people will deliver clothes and household items to the migrants and to the Migrant Center.

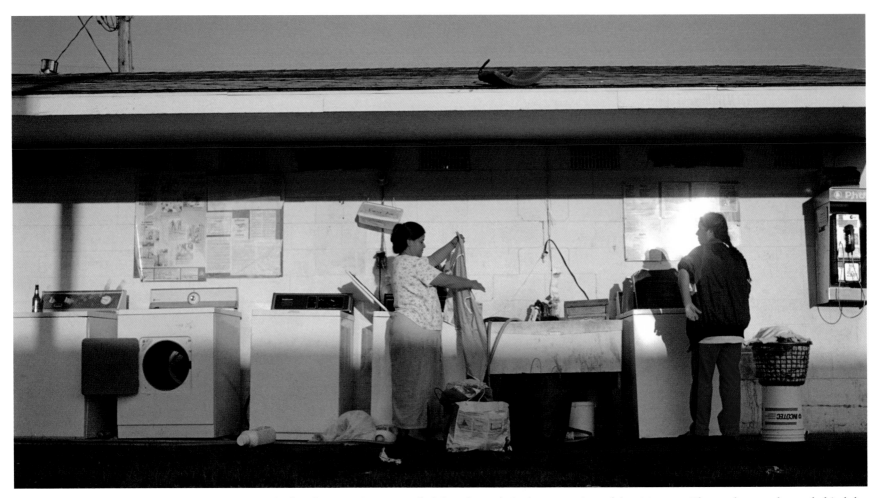

Women in the Chapman Camp start their laundry early in the warm glow of the rising sun. The outdoor wash area behind the shared bathroom facility is an active place, one where women care for children and wash clothes prior to preparing food for the noon lunch break.

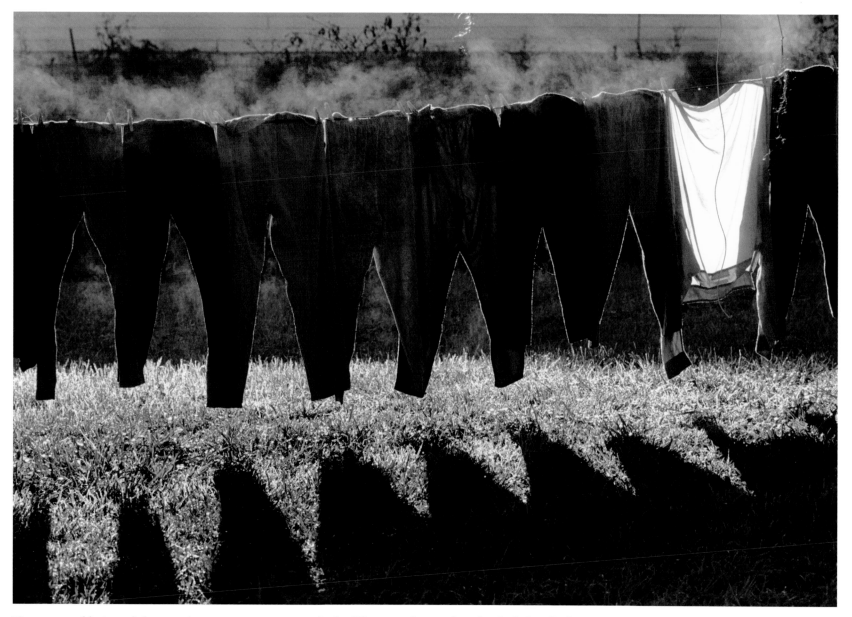

Wet pants, cold air, and the morning sun create steam as the backlit pants glow against the shaded wall of a garage near Chapman Camp.

Ana Laura Milan looks out the window of her home in Chapman Camp. Under the watchful eyes of parents, children play.

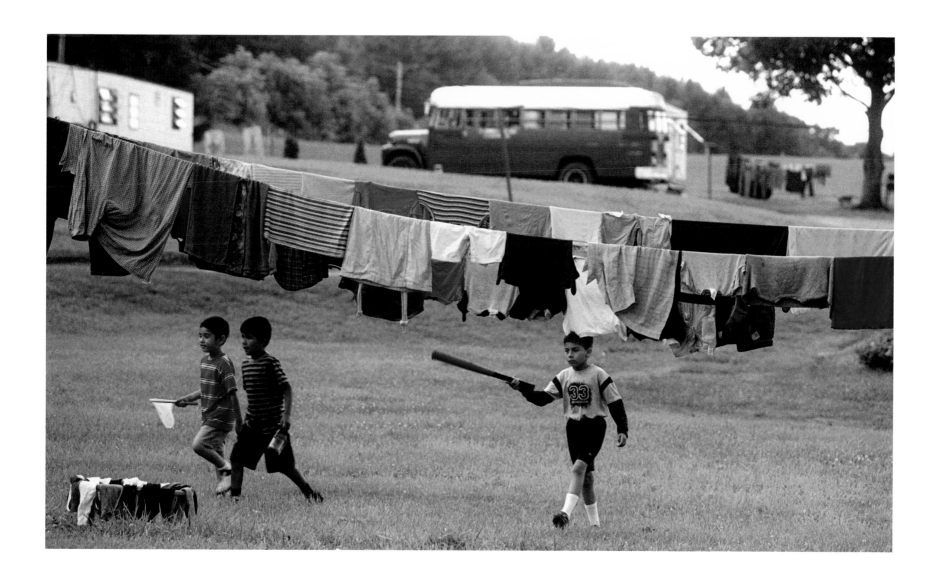

Moisés Mata

I used to travel back and forth from Mexico to Texas to visit friends. And when I was 27 years old, I married a woman who lived in Texas. I took the opportunity to get a residence card and started playing in a band. In nightclubs we played tropical music, slow pieces, and country. I wrote many of the songs for our band, and we recorded them. All my life I have loved to play guitar and sing. Music was my first passion.

During the day I was a driver for the City of Brownsville and continued to play music at night. I would pick up older or disabled people from their homes and drive them to the hospital. I did this job for many years, but the pay was not very good, and I got tired of it. So one day I decided to find another kind of work. I called my father, who was working at the Zellers farm, and he told me I should come up north with my family. He would get me a job on the farm. So for seven years now we have been coming here.

Now I drive a tractor and go behind the crews to water, connecting the water pumps and the irrigation pipes in the fields. It's good work, but it's hard physically. I'm 45 years old now—I like to say I'm 45 years young—but I wonder how many more years I can do this work.

I used to teach sixth- and seventh-grade science in Mexico. I did that for six years, but the salary for a schoolteacher then was very, very low. Now I am considered too old to get a job as a teacher in Mexico. So I want to go to college in the U.S. and get my teaching certificate. Then maybe I can get a job teaching in Texas. If I can, I won't come back to the Zellers farm.

When I'm alone driving the tractor, I often sing. My partner Craig does not speak Spanish, so I don't sing when he's with me. But when I'm with a Mexican crew in the fields, I'll start to sing, and they will sing along. The proudest thing I know is to sing.

My father, too, liked to sing. We would often sing together. Like me, he used to sing while he was working in the fields. He died last year, when he was 66 years old. He had just retired and was living back in Mexico. At the funeral I did not look at him in his coffin because I wanted to remember him how he was alive. Now I think of him every day. I dream of him often. I think he comes to visit me, and I talk to him. He never says much, but he is always smiling. I know he is still living in me.

I always carry a pen and a notebook with me when I'm working, and if an idea for a song comes to my mind, I write it down. Two weeks ago I wrote a *corrido* for my father while driving the tractor, trying to remember how my father was. I often see his crew members in the fields and where my father used to live. Every time I had an idea, I had to stop my tractor and write the words down in my little notebook that I keep in my shirt pocket.

I worked on this *corrido* for two weeks and just finished it. I'm still thinking about the melody because I want to make it different from my other songs. Sometimes I have the idea for a melody first and then I write the words. But sometimes I write the words first, and then I must think of the right melody. For now, I just have the words. It is called "El Corrido de Don Pancho." A *corrido* is a popular Mexican song, like a ballad, that tells the story of a hero or of something that happened in certain place. Well, this is the story of my father. His name was Francisco, but Pancho was his nickname. When I get the melody I will sing it. I will sing this *corrido* for everybody.

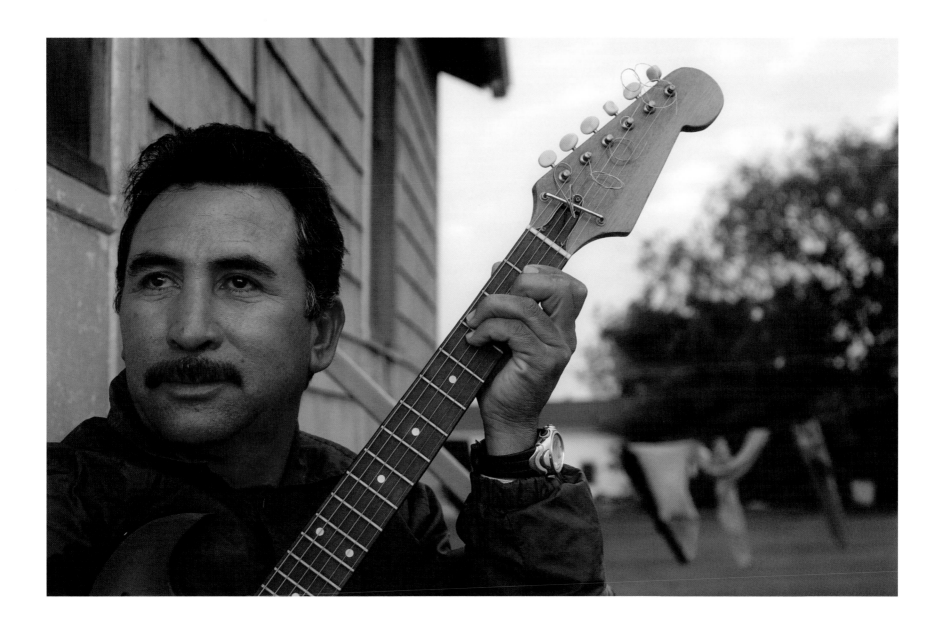

El Corrido de Don Pancho

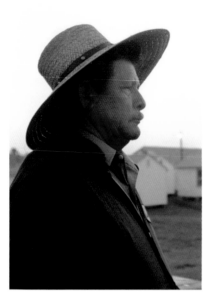

Moisés's father, Francisco Mata.

Voy a cantar un corrido
de un hombre y un gran amigo
su nombre Francisco Mata
y lo digo a todo orgullo
un hombre a carta cabal
y un corazón de oro puro.

Nacido de Matamoros
tierra de gente sincera
trabajador muy honrado
daba amistad por doquiera
no le temía ni a la muerte
aunque de frente la viera.

Radicado en San Fernando
su Tamaulipas querido
la gente lo respetaba
porque sabía ser amigo
pero si habladas le echaban
también era decidido.

Migrante por muchos años
en el estado de Ohio
Siempre ayudaba a su gente
cuando le pedían la mano
beneficio no buscaba
solo ayudar al hermano.

Seis pies abajo era el nombre
de su canción preferida
en todas partes cantaba
era alegre sin medida
cuando muriera quería
mariachis de despedida.

Don Pancho así le llamaban
sus amigos mas queridos
era mi padre señores
por desgracia ya se ha ido
más nunca lo olvidaré
Porque en mi alma sigue vivo.

Don Pancho's Corrido (translated by Mario Morelos)

I will sing a *corrido*
about a man and great friend
his name Francisco Mata
and I say it with all pride
a man with integrity
and a pure gold heart.

Born in Matamoros
land of sincere people
hard worker very honored
he used to spread friendship
 everywhere
was not afraid of death
even when they met face to face.

He lived in San Fernando
His dear Tamaulipas
people respected him
because he knew how to be a friend
but if they talk bad to him
he was also decisive.

Migrant worker for many years
in the state of Ohio
always helped his people
whenever he was asked to give a hand
he did not look for benefit of his own
only to help a brother.

"Six feet under" was the name
of his favorite song
he would sing it everywhere
He was happy without measure
When dying his wish was
a mariachi good-bye.

Don Pancho as they called him
his dearest friends
was my father, gentlemen
unfortunately he has left
but I will never forget him
because he continues to live in my soul.

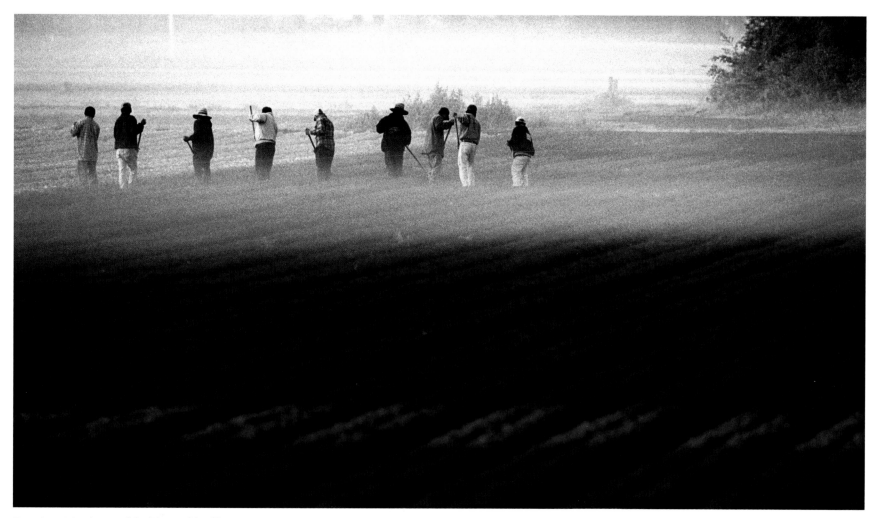

Francisco Mata's crew blocking red leaf lettuce.

Katie Giancola

I've always had an interest in working with Spanish-speaking populations. I started taking Spanish in junior high and did Amigos de las Américas in high school. I knew I wanted to be a doctor, so I got to spend eight weeks in a hospital in Paraguay. Then for my last semester in college, I studied in Guadalajara, Mexico. I love the language and the culture. It's so unique, so bright and colorful.

My first summer here I got paid through my medical school to work as an assistant to Dr. Wurst. I think it's great to see a physician that's advocating for the migrants. That's what I've wanted to do ever since Amigos, to work with underserved people.

I like to be the one that breaks down all stereotypes. When the kids here first see me, they look really scared. They don't know what to make of me because I have light skin and blue eyes. I'm really tall, I'm a female, I'm a student doctor, and I'm speaking Spanish. But then I smile or wink at them, and they just turn into kids anywhere. It's great.

I wish everyone could experience, for once, what it is like to be the visitor in another country, to be the foreigner. I can't imagine my life without it. I definitely wouldn't be the same person I am today.

When I was in Guadalajara, I did a mission trip through a church with 39 Mexicans I did not know beforehand. We went down to the southern state of Oaxaca. I was scared to death. I had no idea where I was going or what I was getting myself into. We worked for 10 days with people in the mountains, and it was the most incredible experience in my life. The third day I was there, I celebrated my twenty-first birthday. They threw me a surprise party under a bunch of mango trees, and I celebrated with a hundred Mexicans I didn't know. They brought me a decorated cake and balloons and sang to me and told me to lean my head over the cake and take a bite out of it. I thought it was strange, but they kept chanting for me to do it. And when I finally did, they pushed my face into the icing. I learned it's a Mexican birthday tradition, the *mordida*. I've never felt so much love poured out by a group of people. These were some of the nicest people I've ever met, and they made me feel so welcome.

Rosa Díaz, celebrating her eighth birthday, has her face pushed into the cake by guests. Every child knows this will happen, but each reacts differently. Rosa tried to blow out the candles quickly and step back, but her mother continued to light them until guests could provide the gentle push.

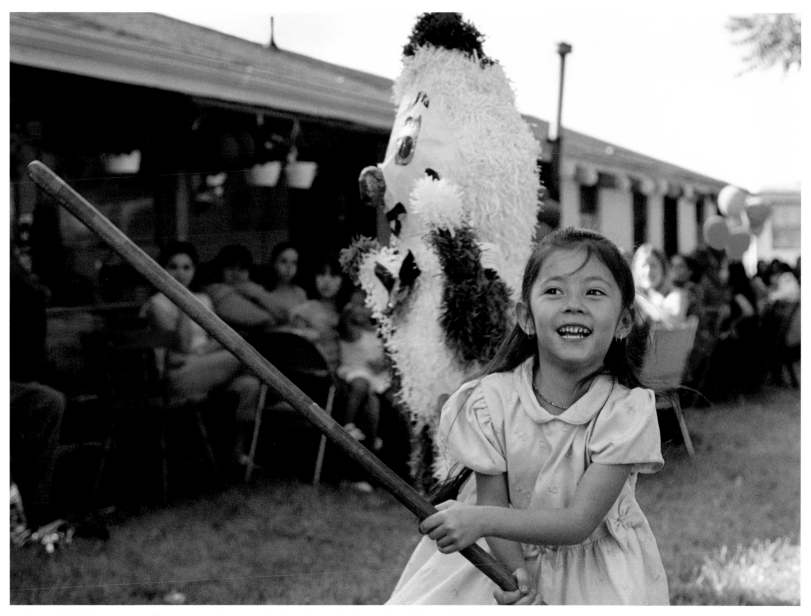

During a birthday party, Melissa Hernández completely misses the bouncing piñata. Birthday parties are community events, with entire families joining in the fun and games.

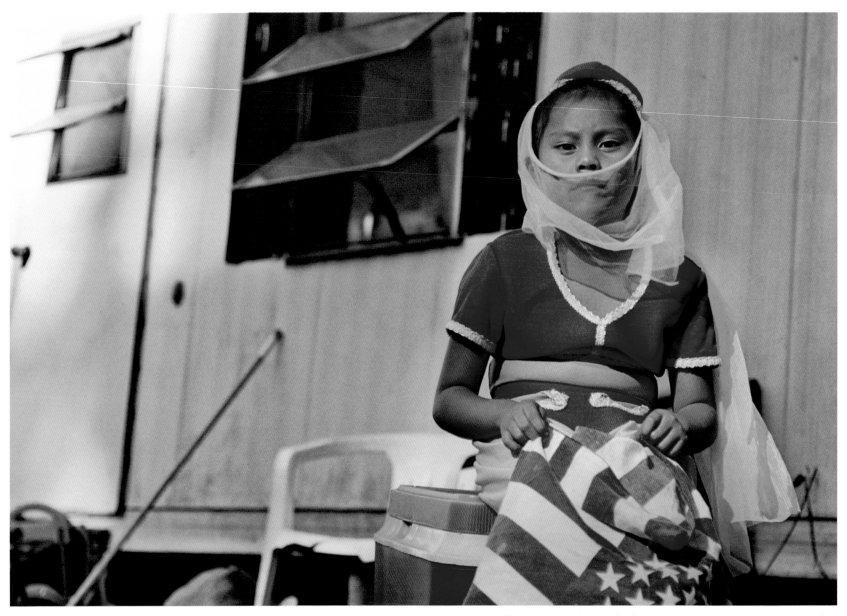

Still in her genie costume, Atalya García holds an American flag as she sits in the shade by a mobile home in Royer Camp. She waits for her turn to participate in activities during a costume party.

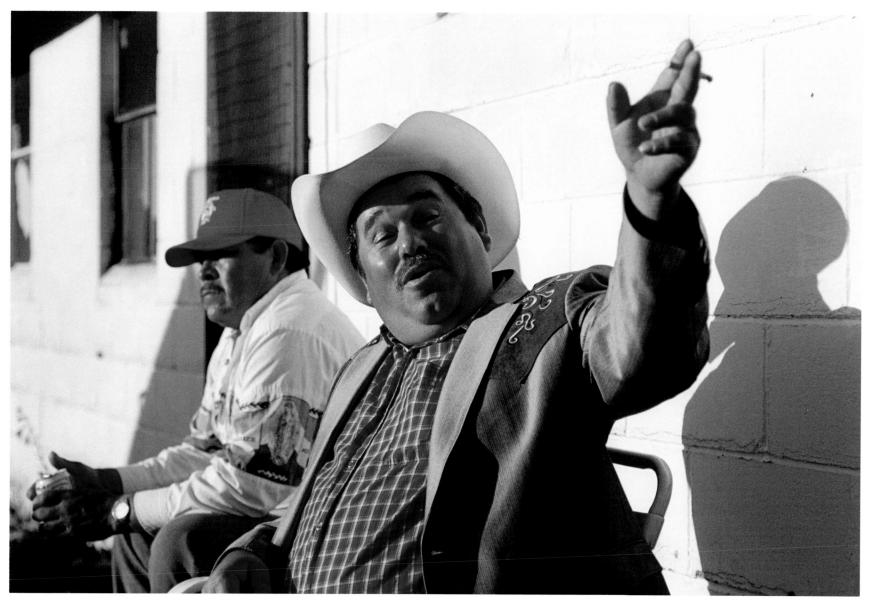

Dressed for the occasion, Juventino Delgado tells stories during a party. At such times, the men often break from the festivities to gather around their trucks, talk, and listen to music.

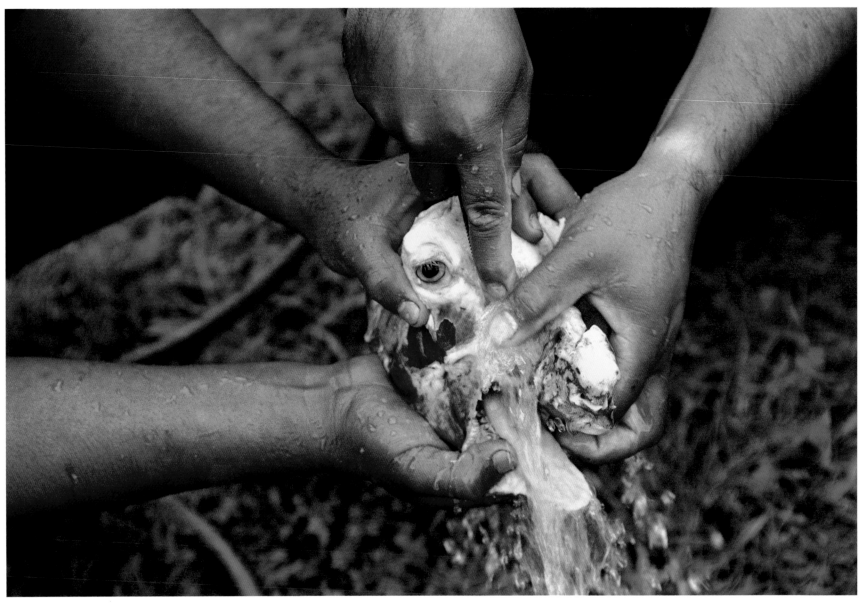

Workers prepare the head of a goat for a Sunday barbeque. The men purchased the animal and butchered it into manageable sections. The slow-cooked meat is covered in a spicy sauce and served with peppers. It will provide two days' worth of meals.

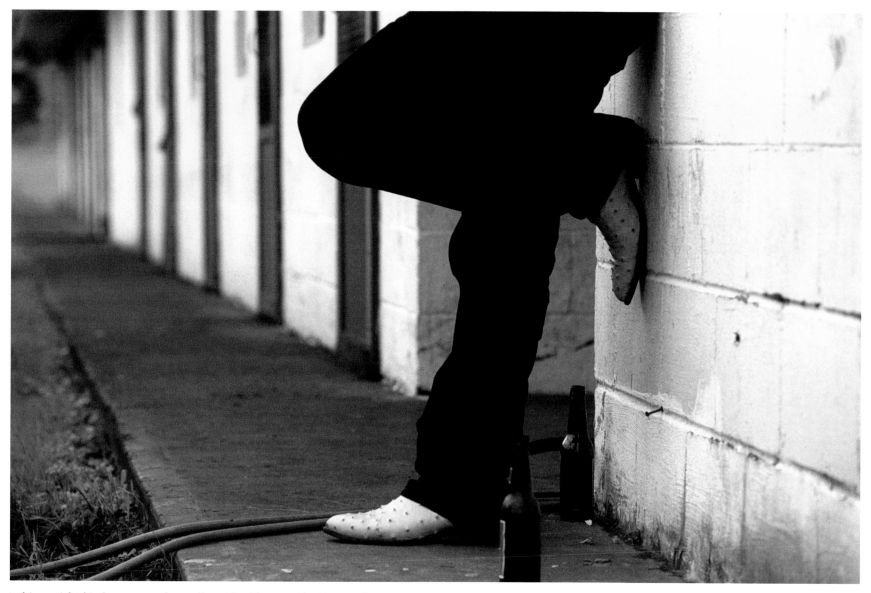

In his ostrich-skin boots, a worker strikes a familiar pose during a cookout at Tope Camp.

Georgina Soto

The first time we came here, I was five years old. It was pretty hard to move here. I remember it like yesterday. I was afraid because I would have to stay alone in the house by myself when my family was working. We didn't know about Head Start then, so I just stayed home the whole day.

I couldn't speak a word of English. I could barely speak Spanish at that age. I used to watch cartoons on TV—*Dragontails, Clifford*—it didn't matter. There was no Spanish channel back then. I'd just watch TV and eat. Sometimes though, every couple of weeks, my family would take me out with them after lunch to sit in the little red truck that they drive around the fields. I'd sit there for a few hours and watch them work so I wouldn't be home alone.

The next year I went to first grade at Marlboro Elementary School. I still didn't really know any English. I had the nicest teacher, Mrs. Weston, and she helped me a lot. She had a book with numbers in Spanish and English, and she tried to teach me things. But I failed first grade because I didn't know enough words. I didn't mind failing that first year. I didn't care. A year goes by fast. Besides, there were two other children from Mexico in our school, a boy and a girl, and they were in kindergarten. So the next year we were in the same first-grade class together. We would help each other. Often one of us would know a word that the other didn't, and that made it easier. We all passed that year, and I haven't failed a grade since. I'm 13, and next year I'll be in eighth grade. I like school, especially now that I know how to speak the language.

I remember when we first came here the couple across the street, Bob and May Nichols, just came over and said if we needed any help to call them. Whenever we had a cookout or a party, we'd invite them, and May would bake a cake and bring it over. Or sometimes when we'd cook something special, we'd take it over to them. And that's how we became friends.

I met another lady, Pat Moore, when she volunteered to go with us on field trips. In the summer she picks me up most days of the week, and I go over to her house and we do a lot of fun things together, like bake and watch movies. And we like to go shopping, too. We'll try on everything in a store and look at each other's outfits. Often we leave without buying a thing and then go to another place. It's funny because the sales people often think we're going to buy something, but usually we don't. Sometimes they ask Pat if we're related. They think I might be her grandchild or something. But Pat says, "No, she's just my friend."

The first couple of years it was pretty hard for me to move back and forth, but now I don't care where I live—here or there—because I have friends in both places.

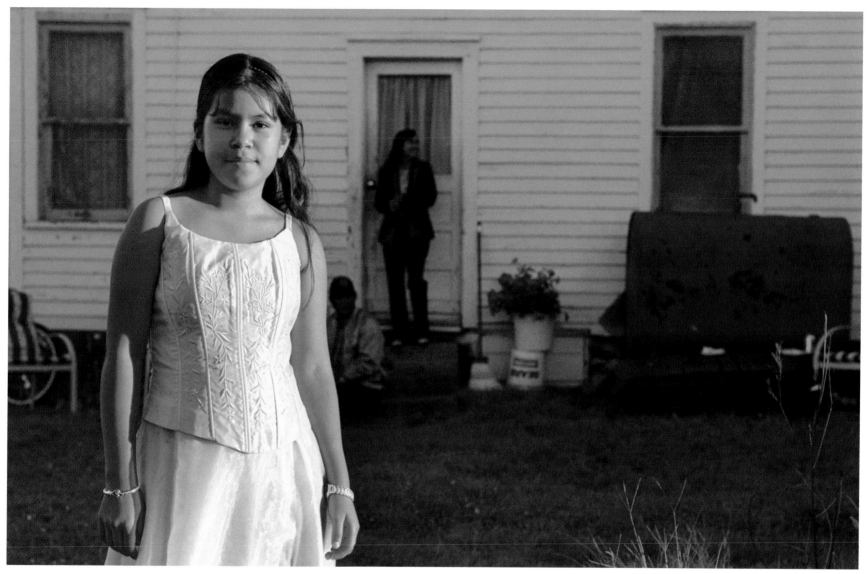

Georgina Soto celebrates during her twelfth-birthday party, which was held in an old garage near their home.

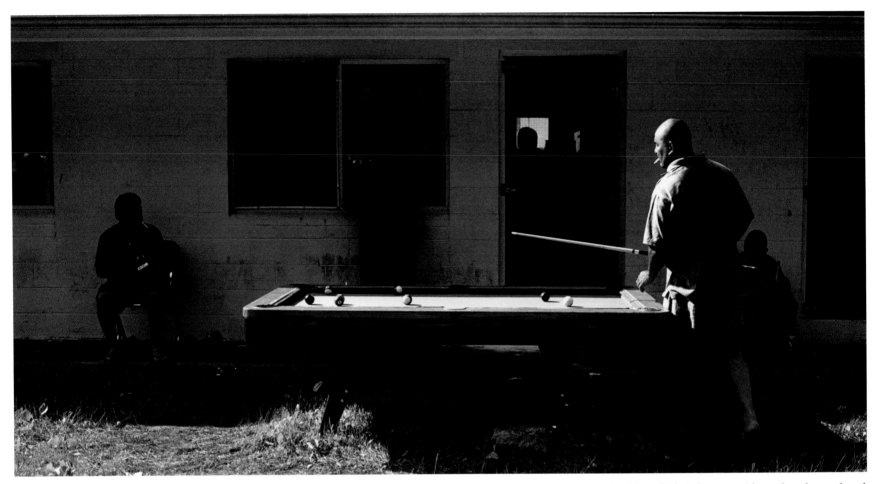

Cipriano Contreras plays pool behind his home in Warner Camp. The pool table, which is kept outside under plywood and plastic to protect it from the weather, was purchased at a garage sale. Garage sales, discount stores, and the weekly thrift sale are popular shopping places for many in the migrant community.

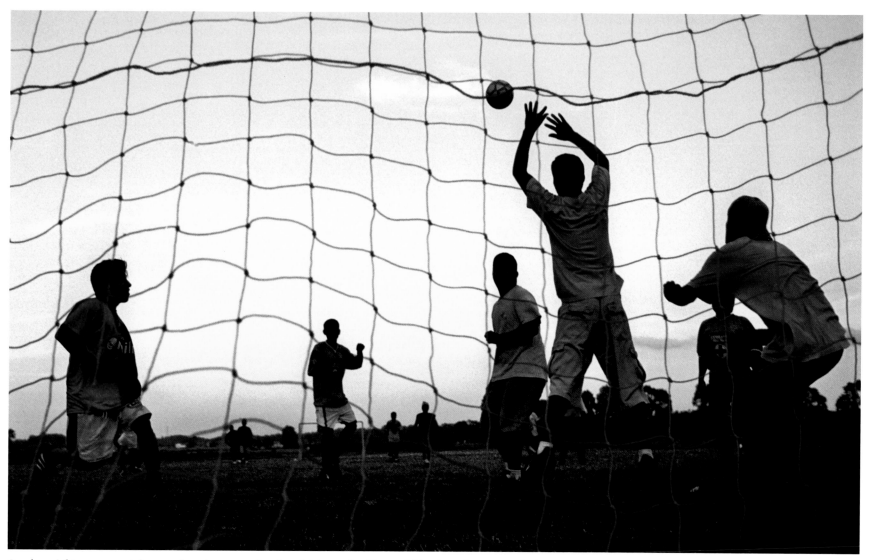

Sunday-night soccer matches are favorite recreational activities as families and friends gather to watch the men compete. Occasionally, they host teams from other Latino immigrant communities.

Religious Life

Enter the small church near the Zellers farm and the first thing you see is the "God is Love" sign. For many of the migrants, religion plays a very important role in their daily family life.

For the Cristianos, the church experience is long and emotional. With eyes closed and arms raised, these Pentacostalist worshipers' dedication and faith is evident in their body language, and their voices fill the church. Small children are held not only by their family members but by others in the church. It's not unusual for a child to go through several loving arms during a service. From the road it is easy to see and hear the worshipers. Music from a live band, whose members are themselves migrants, seeps through every crack and crevice of this cement-block building and spills out the open door.

This small farm church is also a place of worship for the Catholics in the camps. Other churches in surrounding communities support the migrant community, such as St. Joseph's in Randolph and St. Bernard's in Akron. St. Bernard's Church has become a common place for the migrant families to celebrate important religious events.

There have been many visitors who have come to Hartville to join the migrants in their worship, including Bishop John Manz from Chicago and Bishop Martin Amos from Akron. The Hartville Migrant Ministries also organizes an annual trip to Windsor, Ohio, to visit the 50-foot statue of Guadalupe and to share a special Mass there.

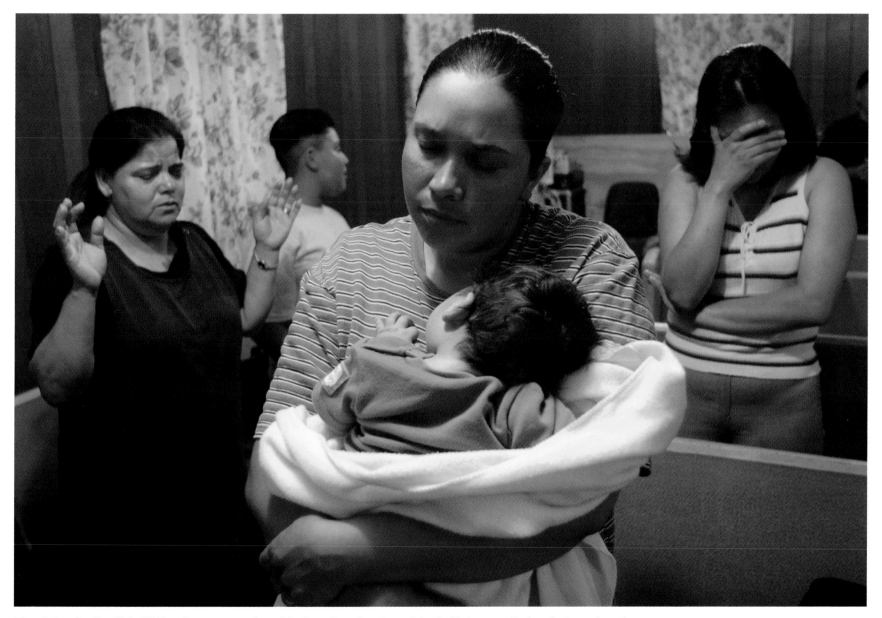

Church is a family affair. While others react to the spirited reading, San Juana Páez holds her son, Carlos, during a three-hour church service at the Graber Chapel near the Zellers farm.

Children pick up flower petals that have fallen from a bouquet as they follow a parent into the church.

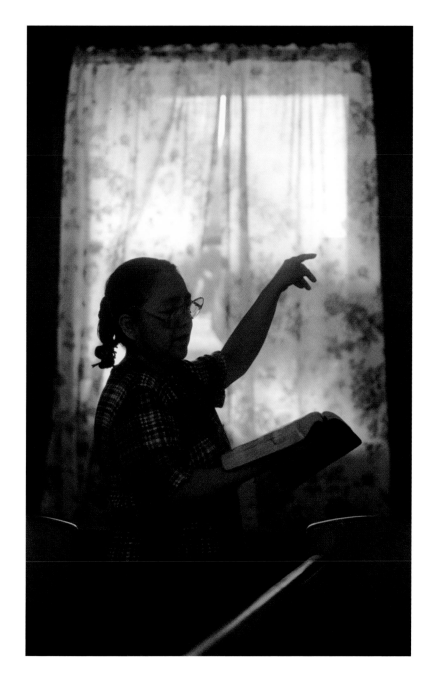

Concepción Vásquez, an Akron resi-
dent and a member of the Nuevo Vida
Church A.D. in Akron, Ohio, offers a
spirited reading from the Bible during a
weekday service at the Graber Chapel.
She joins other members who travel to
the farm church to worship with the
Cristiano members of the migrant com-
munity.

Bishop John Manz

When I was in college seminary, we were assigned work details, so they put me in the kitchen. It just so happened that a year or two before, the diocese had brought up a group of Mexican religious women to do the cooking. So over the course of the next couple of years, they basically taught me Spanish, and that started my interest. About the same time, I worked with a landscaping outfit in the summers to help pay my expenses, and a lot of the men I worked with were migrants, Mexican Americans from Texas or Mexico. The boss used to send me out with their crew because I could communicate with them. They were a big contrast to the Sisters. Their whole outlook on life and their vocabulary were very different, and that piqued my interest even more.

So while I was still in the seminary, I started working at a parish north of Chicago that focused mainly on migrant workers. And in 1968, a couple of years before I was ordained a priest, at the height of the grape strike in California, I decided to join a group working in California with César Chávez, who was a big hero of mine. They gave you room and board and about five bucks a week. But they ended up not organizing that much that summer, so I went to Texas and lived in a border town and visited migrant camps down there for a couple of months.

I have been working with immigrants/migrants since before I was ordained a priest and also for the 10 years I have been a bishop. All three of the parishes I served at as a parish priest over 25 years were predominantly made up of Mexican immigrants. It started out on a personal level and gradually grew into something I felt very committed to, something I thought I could do to help out in some way. Once you begin to learn a language, it becomes no longer an abstract thing, and you get to know individuals, not just a social class of people. That's how barriers are broken down. We all have our prejudices or stereotypes, but the only way to break them down is by getting to know the person. I am a big believer in a common humanity. But first I had to learn the language to communicate with those Sisters in the kitchen, and beyond that it opened the door to another world.

When I came to Hartville, I walked around and went to several of the camps to visit with the migrants and talk with them. I introduced myself and invited them to come to the Mass we were planning to have outdoors on the basketball court. We had arranged for a reception afterward and some music during the Mass. We were supposed to start around one o'clock or so, but by 1:30 hardly anybody was there, which was nothing new to me. You know you can't go into a place like that with a fixed sense of time. You have to be flexible. So by 2:15 there were about 50 or 60 people, and we finally got started.

The best part of my work is meeting the people, talking to and listening to them. Like most of the migrants, I, too, come from a humble background. My people are from farms and small towns. When I was a kid I spent a lot of time on the farm with my grandmother, who was a very simple farm lady. Maybe it goes back to that. I learned from her and from others in my family that this is the way you look at the world and that the work you do is not better or worse than any others'. It's hard to get an exalted opinion of yourself working on a farm when you are standing knee-deep in manure.

When I started working with the migrants back in the mid-to-late '60s in Illinois, a lot of those people ended up staying there and becoming permanent factory workers. There have been efforts in different migrant councils and in some of the churches to help them form unions. The United Farm Workers, for example, accomplished a lot

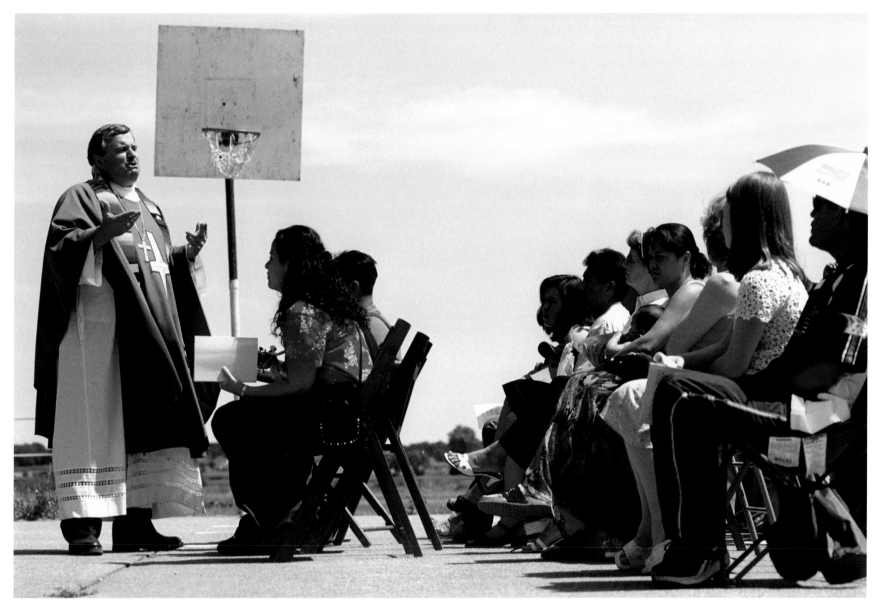

Bishop John Manz celebrates Mass on a basketball court near migrant housing on the Zellers farm. Bishop Manz is the liaison to migrant ministries for the U.S. Conference of Catholic Bishops.

but then, sadly, got involved with intra-union conflicts. So there are still some very bad conditions for the migrants around the country. Many of the big companies will take terrible advantage of the migrants. They know these folks will work for anything, because whatever they're getting here is more than what they're getting where they came from.

As a parish priest, I've had many migrants come up to me and talk about their experiences. But most people do not want to talk about how they crossed over the border. Those who are undocumented don't volunteer that too often. Some of them have gone through some horrible things. There is a priest in California who developed a retreat for migrants, allowing them to talk about their own experiences to try to expunge traumatic memories. He regularly has weekend retreats during which people will tell their own stories of "crossing the border." Some of the stories are very terrible: women who have been raped; men who have been beat up, robbed, and treated as inhuman. These retreats are now conducted by former migrants who previously made the crossing and understand firsthand what these folks have gone through. We need more of this kind of retreat experience throughout the country to help migrants adjust to their new lives.

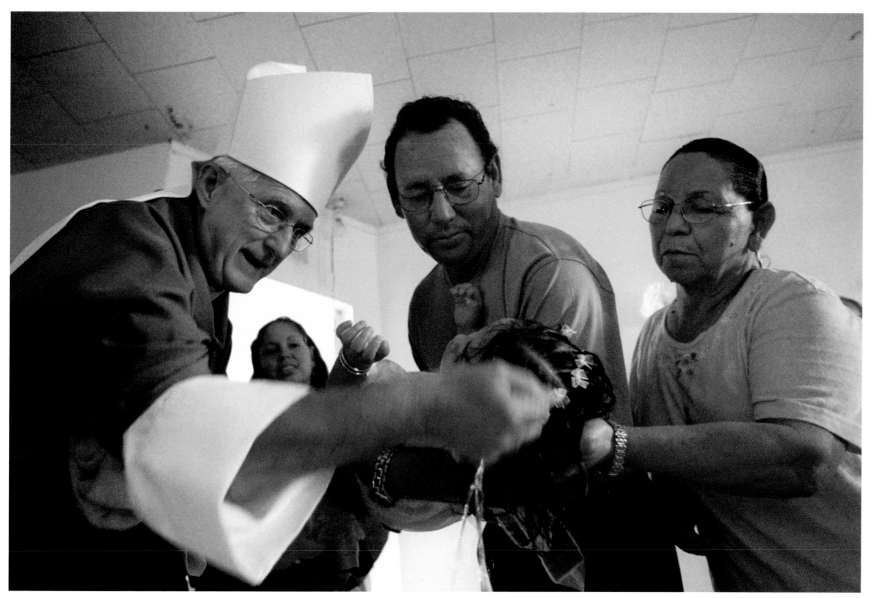

Bishop Martin Amos performs a baptism at the conclusion of the third and final Spanish-language Mass for 2005 at the Graber Chapel. With mother Veronica Tovar looking on, José A. Tovar and María del Pilar Martinez hold Pilar Montelongo over a basin of holy water. Afterward, those in attendance celebrated with the family during a reception outside the church.

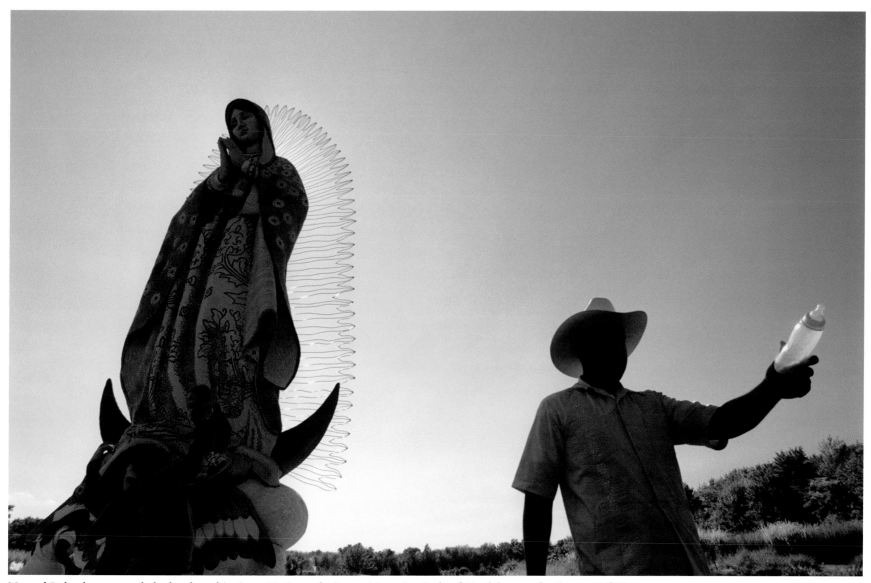

Manuel Delgado passes a baby bottle to his sister, Mariana, during a visit to Our Lady of Guadalupe at the Servants of Mary Center for Peace in Windsor, Ohio. More than 80 members of the migrant community gathered at the center for a Spanish Mass and a visit to the statue of the beloved figure. The annual trip is a highlight for Catholics in the Latino migrant community.

Sister Teresa Ann Wolf, OSB

A long time ago I provided pastoral ministry at the Papago Reservation in southwestern Arizona, which touches the Mexican border. Because I was working with different villages, I was on the road a lot, and many times I would encounter Mexicans coming through the desert looking for work. As a pastoral team, of course, we knew it was against the law. At that time the numbers were not nearly as great as they are today. And the dangers were not as great, either. But we knew they were always at risk. It was easy for them to die in the desert.

So I would pick them up and take them to the closest town from the reservation, which was Casa Grande. I knew a Mexican American man who had a gas station there. He told me not to bring them to him, because he would be liable, but to drop them off a few blocks away, point them in his direction, and tell them they could get water at his station. "Then I can't help it," he said, "if they ask me where to go."

So I did that, and it awakened in me a greater interest in social justice and worker issues. Why is it that this is happening? What are the pressures on both sides of the borders? What are these people's rights as human beings? What are our obligations? I began to think, what more could I do than simply give rides to the few people I saw trying to cross the desert? For one thing, it spurred me to want to improve my Spanish.

From that reservation, I volunteered to go to Guatemala and then to Peru. When I came back from Peru, I didn't want to lose the Spanish that I'd struggled so hard to learn or to stop working with the Hispanic population. I thought I'd have to go to Texas or back to Arizona. I didn't realize there were Spanish-speaking people all over the United States, nearly everywhere.

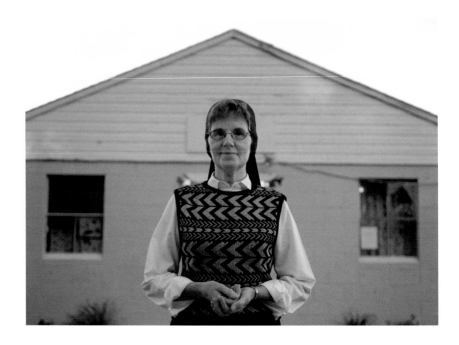

After working with Hispanic populations in Minnesota and Wisconsin, I am now the coordinator of pastoral care for migrants and refugees for the Tri-Diocesan Mobile Migrant Ministry of the dioceses of Cleveland, Columbus, and Youngstown. I work with migrants and refugees, newcomers, and recent immigrants in this area. And we know, practically speaking, that about 95 percent of these newcomers are Spanish speaking. I usually go out to the people; very few of them come to my office in Canton. During the summer, I may go several times a week to the Hartville area to visit people in their homes or in the hospital, to pray with them, to help them in any way that I can.

I think especially since the Second Vatican Council, social justice and human rights issues and workers' rights have become much more prominent in the Church, although not all Catholics are in agreement. There is a group that believes if you go to church on Sundays and say your prayers, that is enough; politics and social action should

not enter into religion. Well, you can hardly live the Gospel, much less preach it, if you don't take seriously what Jesus says about helping the poor and oppressed and caring for others.

Recently the Mexican and American bishops met to address some of these issues. They published a pastoral letter, *Strangers No Longer: Together on the Journey of Hope,* which talks about the dangers of migration and trying to keep families together. This kind of support is really needed, and yet the sad reality is that some dioceses have other priorities and are decreasing their support for migrant ministry just at a time when it is most needed.

I think many times when people hear statistics of how many Latinos are in the U.S. or in Ohio or in Stark County, they are amazed. They simply don't believe it because they don't see these people. There is a tendency for Hispanics to be invisible. Sometimes it has to do with past history. They have had some very painful experiences. They suffer from prejudice, so naturally they want to escape notice. Most of them fear that if they make a complaint, they will be deported or something bad will happen to them.

Because I have worked with Latinos in Arizona, Latin America, Minnesota, Wisconsin, and now in Ohio, I feel that in many ways I'm a migrant, too. I love what I do; I wouldn't want to do anything else. This is fulfilling work. These are good people, and we are growing together. It's an important, exciting ministry of the Church and much needed. We cannot be intimidated and let migrants and recent immigrants be pushed further into the margins and become even more invisible. They have a right to live their lives with respect and dignity. They have a right to be seen and heard.

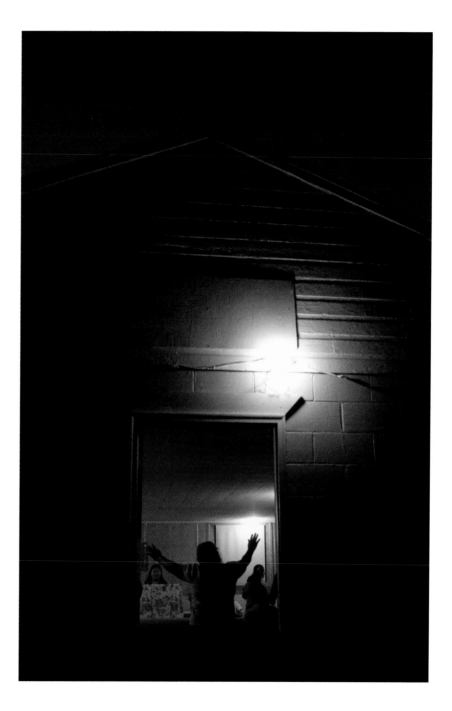

At dusk, the door remains open at the Graber Chapel, where one can get a glimpse of the passion and the importance of religion within the Hispanic community.

La Familia

Beginning with a single Latino family in 1994, there are now more than 50 families living in the camps and the surrounding community. On the Zellers farm, however, nearly all of the families have been drawn to the area by four principal extended families. A number of the returning workers have successfully applied for and received U.S. citizenship. They have established roots in the community. Some have married into local families or purchased homes in the area.

Workers that do not migrate with their families continue to provide support by sending portions of their earnings home. In 2005, the amount of money workers in the States sent home to their families exceeded $20 billion. This not only offers proof of a migrant worker's dedication to family but also represents the sacrifices so many workers make by leaving loved ones behind to provide better lives for their families.

Those who return annually have established a community on the perimeter of the farm fields. Over the last 10 years, they have built friendships and stable lives. Important family events and traditions are celebrated and shared not only with family and fellow workers but also with those Americans who have become an integral part of the migrants' lives. This deep connection beyond the farm community strengthens their northeast Ohio ties and expands their sense of *La Familia.*

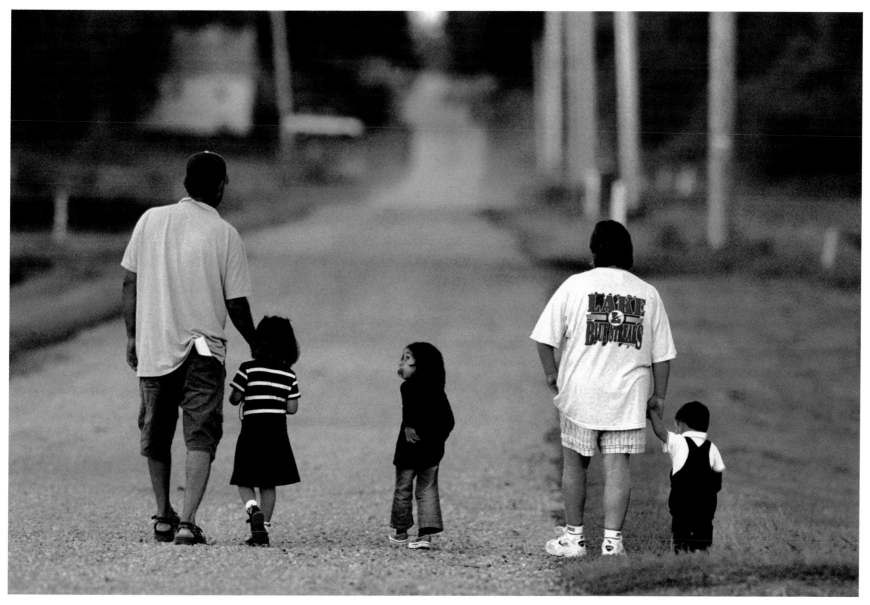

Mariano, Kaylee, Samantha, Mónica, and Ezequiel Delgado take advantage of a peaceful evening and go for a walk on Graening Street near the farm. Evening is the time when workers reunite with their families after a day in the fields.

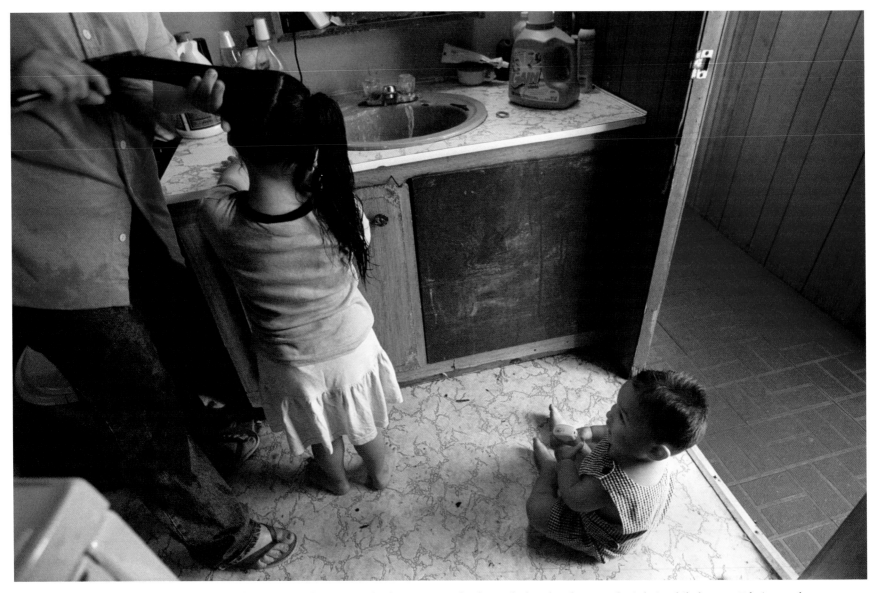

After their Sunday-evening bath, Mariana Delgado combs her daughter Jocelyn's hair while her son Edwin watches.

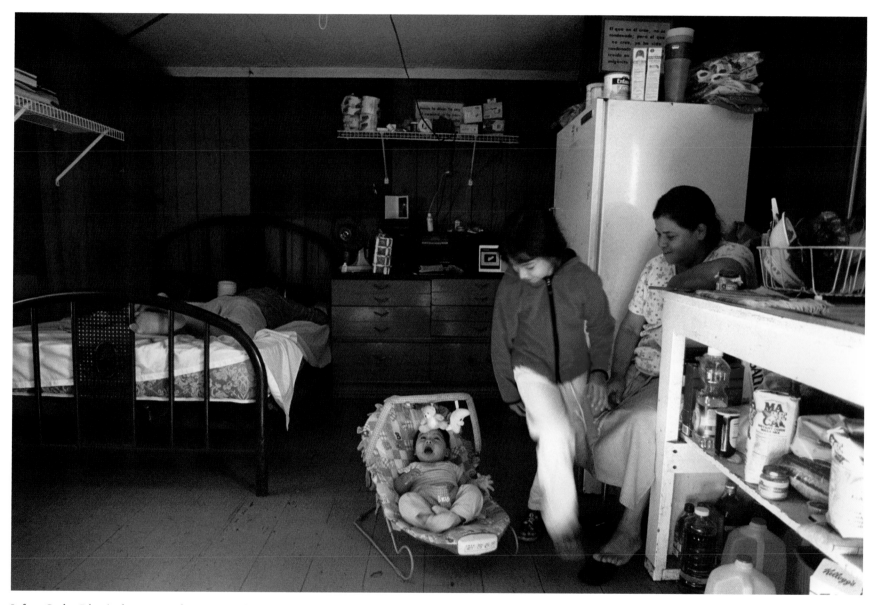

Infant Carlos Páez is the center of attention when his grandmother, María Rodríguez, watches him and other children.

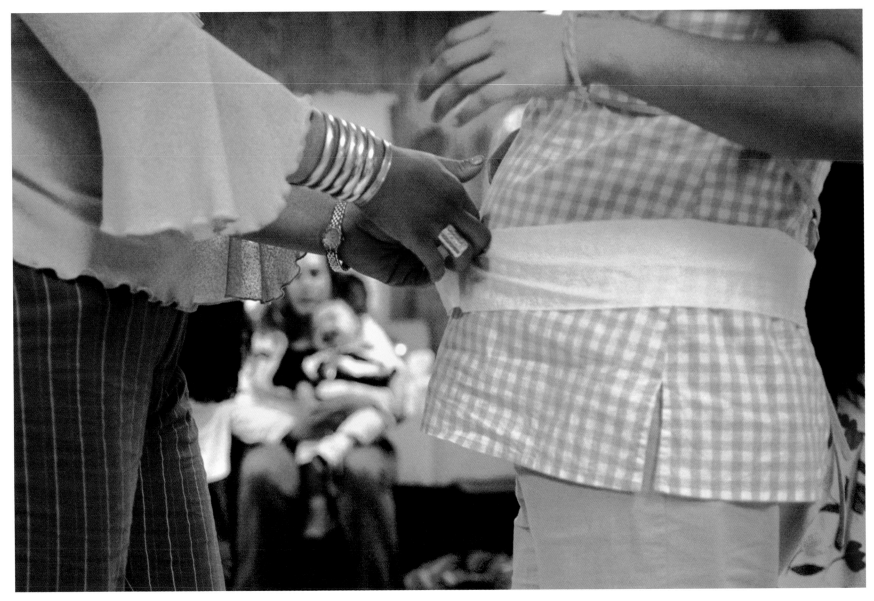

Guests at Maribel Díaz's baby shower take their best guesses as to the size of her expectant belly.

Rafael Gutiérrez presses his hand on the glass of the nursery at Aultman Hospital while he watches his newborn son through the window. The family came to Ohio a month before they were scheduled to begin working to benefit from the quality care of this local hospital.

Rafael Gutiérrez introduces the newest member of the family, Rafael Jr., to his daughters, Beatrice and Nancy.

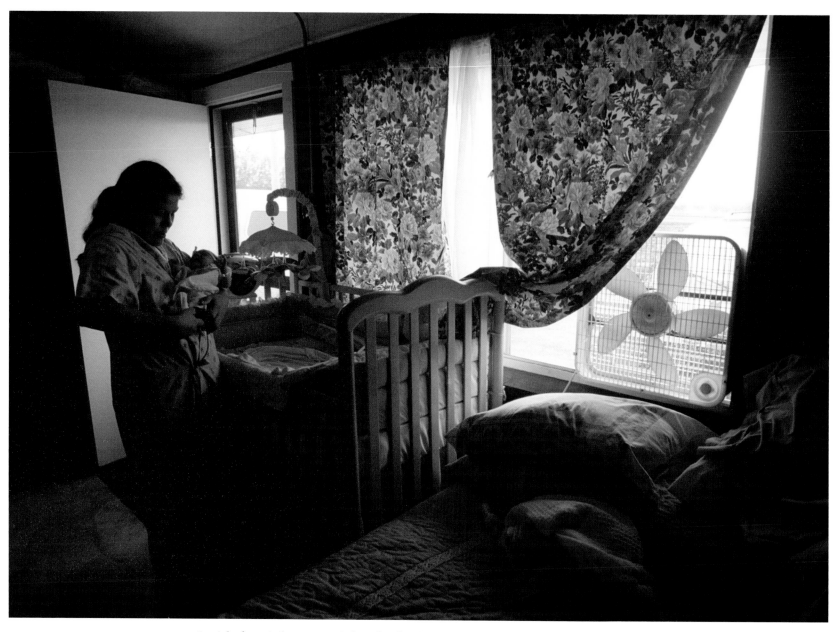

Straight from Aultman Hospital, and still in her gown, Erika Contreras places her newborn daughter, Vanessa, in her crib.

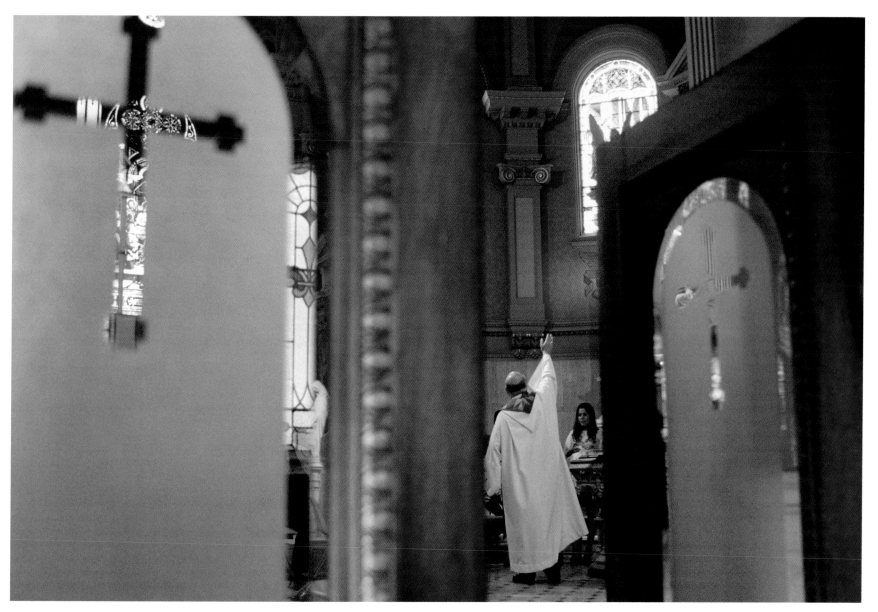

The Reverend Paul E. Schindler performs a baptism for a migrant family at St. Bernard's Church in Akron. The landmark church has become a haven of worship for Latinos because they offer religious services in Spanish.

Deyanira "Deedee" Mata

When I turned 15 last year, my parents asked me if I wanted to have a *quinceañera*. I said I didn't want to have one because it would cost too much money. I told them they ought to put that money into our house in Texas instead. Almost every day they would ask me, "Are you sure you don't want a *quinceañera?*" I would be like, "Yes, I'm sure. Just put that money into the house."

But now that I see how they are preparing for my sister's *quinceañera,* I think, "Why didn't I have one?" It's really exciting to see what she's going to wear and where she is going to have it and the type of music and who we are going to invite. Everything is exciting about it.

Even though her birthday was in June, she is going to wait to have it in December, when we are back in Texas. We are going to have it across the border in Matamoros, Mexico, on a Friday night. It's like a Sweet Sixteen party, only we are celebrating 15 years of her life. We'll invite about 300 people. There will be a lot of music and food, and all our family and friends from Mexico and Texas will come. It will start around seven in the evening and won't end until midnight or one A.M.

My mom says I'm more excited about this *quinceañera* than my sister is. My mom thinks I'm going to take over the party once we are there. I told her I wouldn't. But everybody knows I'm very excited about it since I didn't have one myself.

My sister will dance with my dad first, and then she will dance with her *chambelán,* her escort. And then the 15 girls who are her *damas* will dance with their *chambelanes.* They come into the center of the room and dance the three songs that they've practiced, and then anybody can dance. I was in a *quinceañera* my freshman year, and I had to go to practices three days a week for a month to learn the steps for just three songs. We had to choose the songs and make up the steps, so it's kind of hard work.

When we get back to Texas, we'll see who my sister will chose as her *chambelán.* We don't even know who our *damas* are going to be. We have a lot of work to do once we get back to Texas. My mom is the one who has good taste, so she will choose the decorations. She already knows what colors she wants. My sister's dress has to be pink. Sometimes girls wear baby-blue or yellow, but the typical color for a *quinceañera* is pink. It's like a wedding dress, puffy and big.

I've never been to a *quinceañera* in Ohio. I think people always wait until they are down in Texas or Mexico, where their families are, to have them. I've been to many birthday parties here, but never a *quinceañera.*

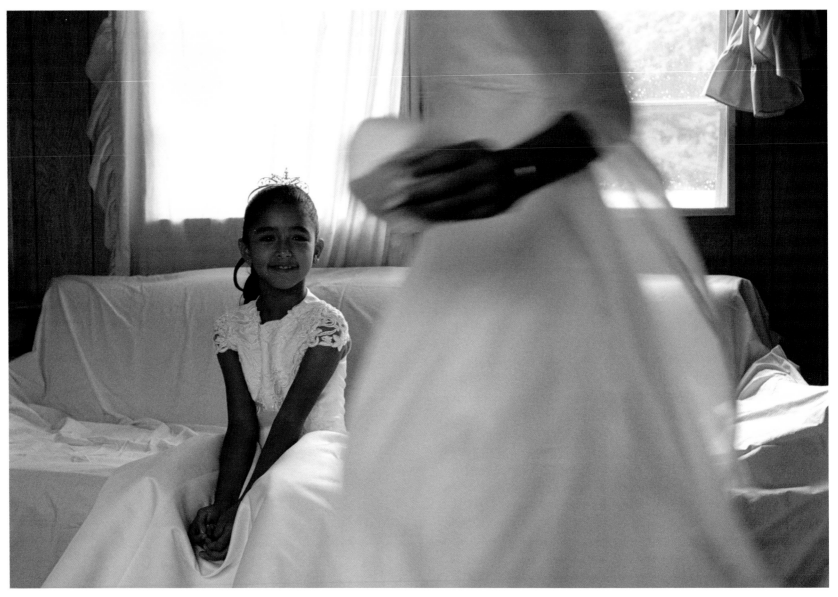

Jasmine Mata waits patiently while her sister, Melissa, gets ready for their first communion. While the children were dressing, their grandfather was preparing his van for a cross-country trip to Texas. His work on the farm was done, but he stayed for their big day.

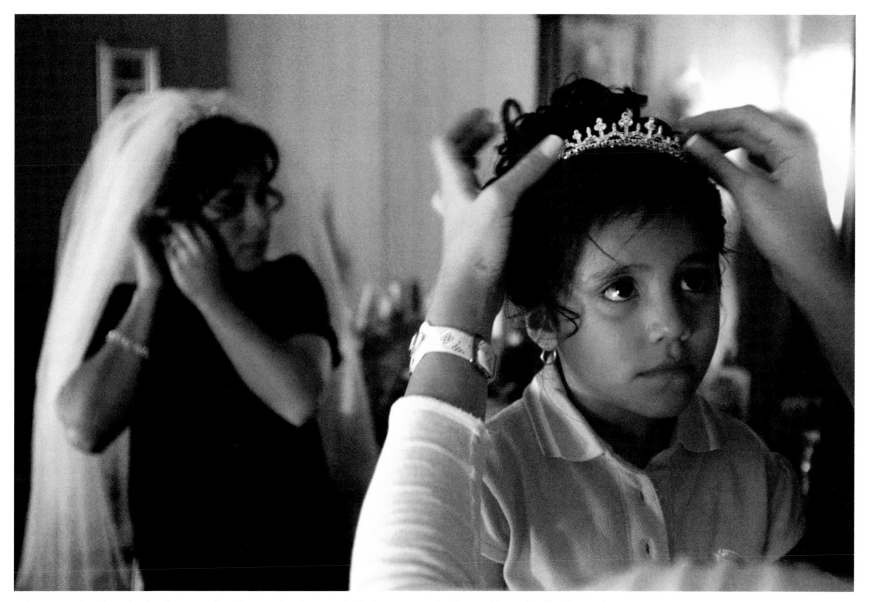

Celeste Martínez has the finishing touches done to her hair as the ladies prepare for the wedding of Jeff Miller and Adriana Martínez. Wearing a crown is customary at important Latino family events, and while hers was being placed, the bride was busy attaching her veil. A few of the migrants have married members of the local community.

first and then open a salon here. My mom doesn't want to go back to Mexico. She says, "The only reason I wanted to go back was your grandma, but she's gone. Now I have no reason to go back."

I still feel the need to have my grandmother around. In some ways I feel like she was here for my wedding and that she has seen my baby. I'm saving my wedding bouquet because I want to put it on her grave when I go back to Mexico.

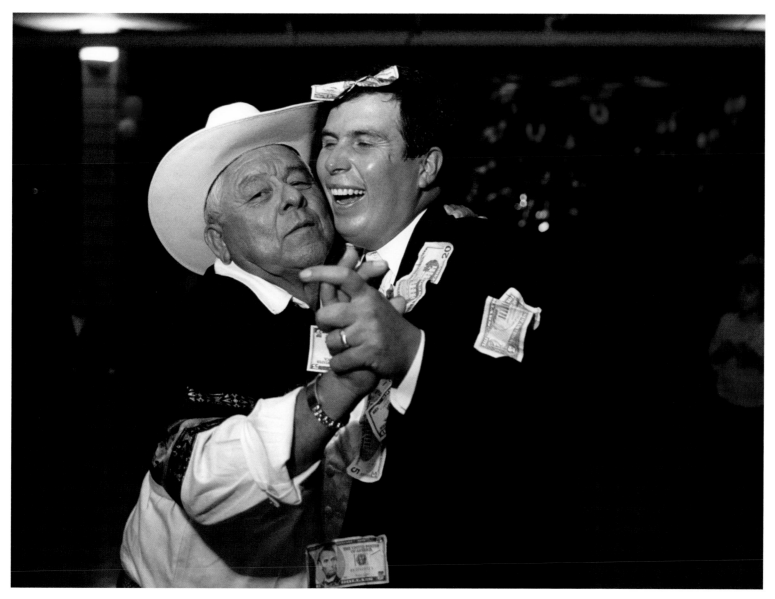

During a humorous moment, a guest pays to dance with Roberto DeLeón during the reception that followed Roberto's marriage to Erika Contreras. During the traditional money dance, dollar bills are pinned to the bride and groom before guests dance with them.

Cipriano Contreras

I was born in Matamoros, Mexico, and raised in the streets, in a very violent neighborhood. I learned to survive. That was my job. There is a lot of violence and drugs and guns in Matamoros, like in many other big cities. For 14 years I was a bodyguard and a cop. It was a hard life. I could survive there now, but I didn't want that for my children. I was afraid that if we had stayed in Matamoros, my sons would end up on the streets and my daughter would get into trouble. So I came to the United States to look for a better life for my family.

We were one of the first families in the area to come here. We started working at the Zellers in 1994, about the time the Sotos came. I wanted my children to learn how to speak English and to finish school in the U.S. There are a lot of opportunities for bilingual people here and in Mexico. There are many American companies, like Nike, and the office employees all speak English. You can find a better paying job if you can speak both languages.

You can't ask for anything more here—comfortable housing, an honest job. It's a lot different when you are working on a farm and you don't have to worry about watching your back. You don't have to keep your mind on surviving. You can just concentrate on your work and relax. And you know that your children are safe in school.

I am crew leader in the fields. I check to make sure that people are doing their job. I write down how many crates we fill and the time it takes. I am thankful that the Zellers gave me a chance to have this job. If I could work here all year and not travel back and forth, I would. But when it gets cold, we go to Georgia to work.

It's hard being in another country with a different culture and to keep your own culture with your family, despite all the influences. That is one of the things that I value the most: to pass on the Mexican culture and values to my children. The most important thing for me, as a father, was that my daughter, Erika, my only daughter, was married in white, in a church, and she was sure about her decision. Of course, nothing is perfect in life, and at the reception the band got drunk and stopped playing, and there were other problems. But it didn't matter. That wasn't very important to me. The most important thing for me was that my daughter was happy to get married and did it the right way.

I know almost everybody in the area, and I have a good relationship with all of them. So we invited all the families on the farm to the wedding, including the Zellers and people from the neighboring farm, too. My wife, Aracely, was in charge of everything for the wedding. She even got my clothes ready. My job was to arrive on time, because I had a lot of work in the fields that day. The Zellers gave everyone permission to stop at 11 o'clock that Saturday, an hour early. That morning we needed to harvest a six-acre field of cilantro before quitting. So David and Kenny Zellers sent a second crew out to help my crew, and they came out themselves to make boxes and to help pack them. We were all working together to finish on time, and we did. I know the Zellers wanted to leave early also to get ready for the wedding.

At the reception we all did the traditional rabbit dance, where the guests line up behind the bride and groom and dance in a long line with a hop. It's symbolic. It means we are wishing them a big and happy family.

Of course, time goes by and things may turn out differently. And it's never the way one thinks from the beginning. But I am proud that we had a proper Mexican wedding in Ohio and that I raised my daughter right. I've seen many of the children here grow up and start working in the fields. Now both my sons and my daughter work for the Zellers. This year will be 10 years that we've been coming here. Ten years. These are short words to describe a long time.

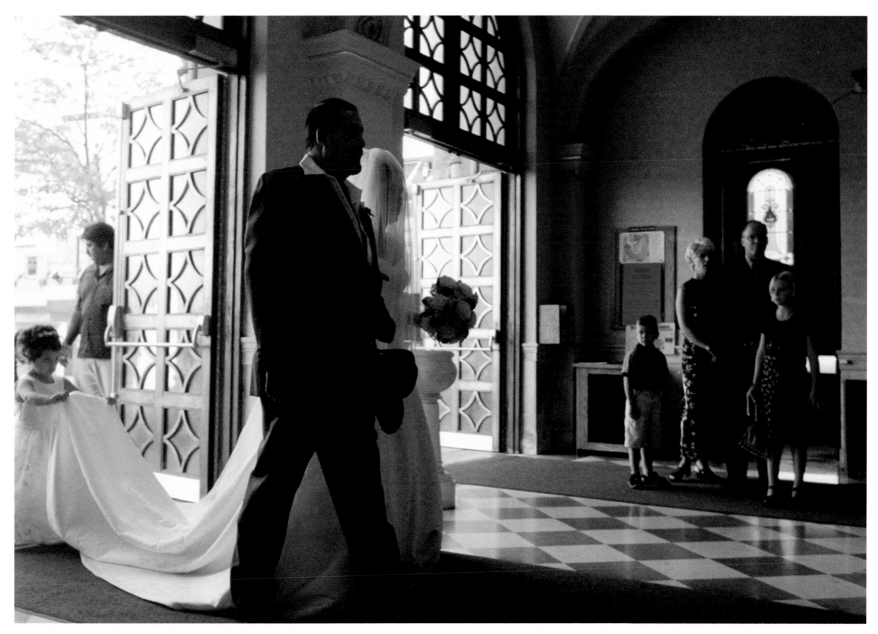

Cipriano Contreras escorts his daughter Erika into St. Bernard's Church in Akron as friends and family gather to witness her marriage to Roberto DeLeón. Grower Jeff Zellers and his family, included in the special event, are in the background.

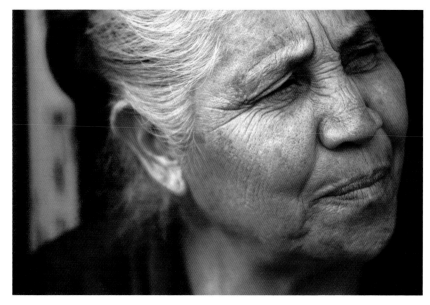

Consuelo Orneals cares for the children while the parents work the fields.

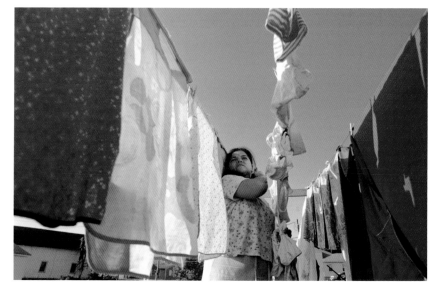

María Elena Rodríguez de Páez hangs clothes at Chapman Camp.

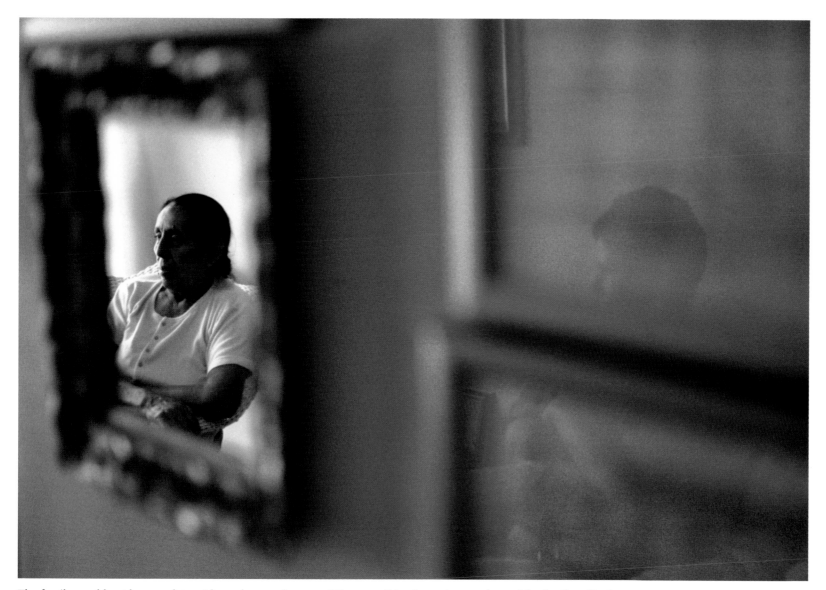

The family would not be complete without the grandparents. When possible, the senior members of the family will migrate as well. Not only is there great personal value when the family remains together, but the grandparents also provide a valuable contribution to the economic stability of the family by tending to the home and caring for the children while the parents are working in the fields.

May Nichols

I remember the first day I met Víctor Félix. He was visiting his grandmother and he walked outside. I was right here on the porch, and I said, "Well hi there!" And he said, "Hi!" So I said, "What's your name?" And he said, "Víctor." "Well that's a pretty name," I said. And that's how I got acquainted with Víctor and his family. I just said, "Hi there!"

I started babysitting Víctor in the daytime while his parents worked in the fields. I always said he was my Mexican grandson. I told all my kids and grandkids, "He's just like you. He's gonna be one of my grandkids." I bought him his first bicycle at the Church of the Brethren yard sale in Hartville for five bucks. Well that just tickled him to death. He learned to ride it right out here along the house and out in the backyard. He was just overwhelmed.

Even today that little guy calls me at least once a month and talks to me on the phone. And you can just tell in his voice that he wants to come so badly to see us that he can hardly stand it. He's 14 now, and they live in Florida year-round. But he still calls me.

After Víctor Félix and his family left, the Soto family moved into the big house across the street. I remember it wasn't long until one night we had our windows up while we were sleeping, and no better than I can hear, I heard this kid crying. I thought, oh what on earth is wrong with that child? She sounds like she's really bad sick! So the next day I went over and I asked, "What's wrong with your little girl? Does she need medical help?" They said her jaw was swollen from a toothache. I said if there's something I can do to help I would. But their little girl, Brianna, wouldn't have nothing to do with anybody. Well, I had a new toy here that was on four wheels that she could put her little baby doll in and push. So I took that over and that just did it. She

started playing with it, and that little girl was tickled to death. They finally got her all fixed up so that swollen jaw went down. And after that it wasn't long before they come and asked me if I would watch Brianna while they all worked.

They would bring her over still sleeping in her nightclothes at 6:50, and I would have her bed made right here on our love seat and would cover her up. And God bless her heart, sometimes she'd sleep till 11 o'clock in the morning. Once in a while she'd sleep till they come back at noon to eat, and they just couldn't believe it. They thought that was really extraordinary. Usually they would take her home for their lunch break, but sometimes she wouldn't want to go home.

Now, my husband, Bob—well, she's his girl too, because he plays with her. They play little card games like Go Fish and Old Maid. He tells her she cheats, and she says, "No, you cheated!"

Sometimes Brianna will come over here in the evening after her mother has cooked a meal, and if she didn't want to eat what her mother fixed, she'll rub her tummy and lick her lips. I'll say, "Are you hungry?" And she'll say, "Yes." And she'll go right in and sit down at the table and eat a meal with me and Bob. Many times that child has done that. She says, "Can you be my American grandma?" I say, "Well, certainly Brianna!" She claims that we're her American grandparents.

The other day Bob was sitting out on the porch and he said, "You know, I really miss them Sotos." I do too. You don't see anybody there. You don't have anybody waving, or saying hi. But I keep in touch with them. I always send them a Christmas card. And if anything happens that I feel they would want to know, I jot it down and send them a quick note. Once in a while they'll call, especially around Christmas.

Every year when they return in March, they always bring us a gift from Mexico. One year they brought Bob one of those big round sombreros. Another year they brought a poncho. Last year they brought

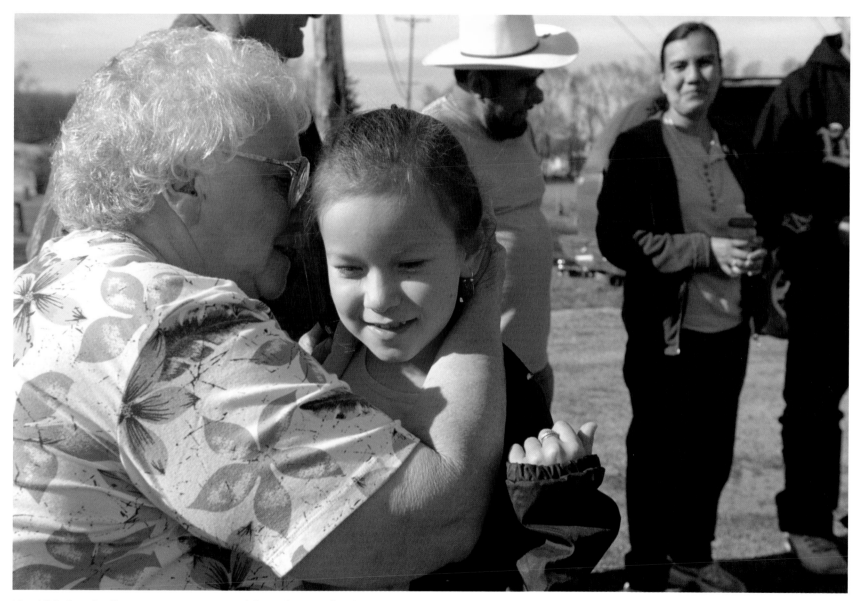

May Nichols, who lives across Duquette Road from the Soto family, surprises Brianna Soto with a cake and an impromptu celebration on the day of her ninth birthday. The Nichols and Soto families have become good friends, and Brianna frequently visits the Nichols home. May considers Brianna her "Mexican granddaughter."

us a Mexican blanket that fits Bob's bed, and it's as soft as anything could ever be. In the wintertime he wraps up in that and doesn't even know the snow's on the ground. It's so warm.

Until we moved here to Hartville, I'd never met a migrant worker. I didn't know what they were. Never heard of them. I never dreamed that I would have the opportunity to meet people of a different culture like this and learn to know them and get to be close with them.

But they moved right across the street from me, and pretty soon I learned they were nice people. It's really something. I was always told when you quit learning you quit living.

I'd take any one of them, keep them forever, long as I live, if they wanted to stay here with me and Bob. They're special people—just unexplainable, special people.

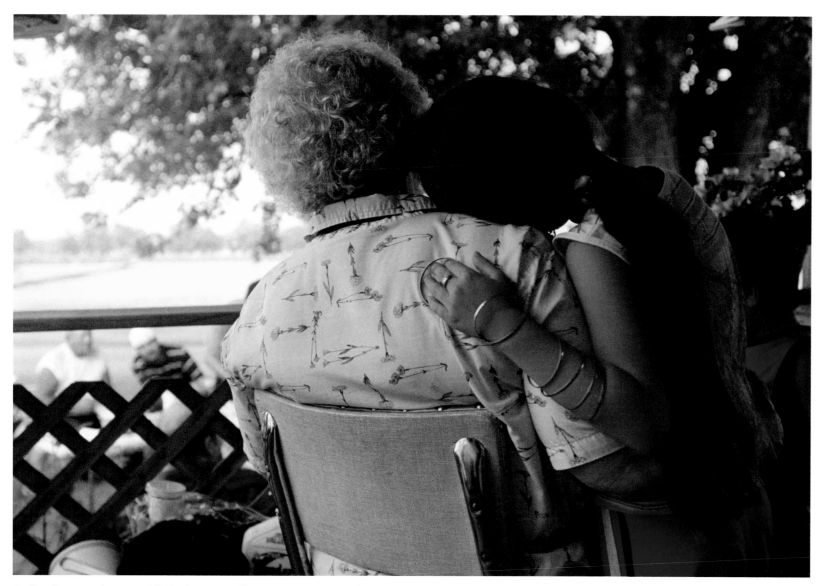

On her front porch, May Nichols shares an affectionate moment with Brianna Soto during an outdoor dinner she planned for the Sotos after a day in the fields. Her husband, Bob, and Iván Soto are in the background. The front porch is a favorite place for May, where she passes many a summer day. From her porch she can see the Soto home, other migrant housing, and the Zellers farm fields.

Migrating

Soon it will be time to leave again. Migrating begins after the first frost and before the first snow. As the days grow shorter and the evenings colder, every effort is made to save the remaining crops from the frigid temperatures. With each successful harvest day, there will be less work. By mid-October the growers will announce the final work day. The majority of the workers will return to the border towns of Texas. Some will go to other southern states such as Florida and Georgia. Others will return to their homes in Mexico.

Several days before the announcement of the last day of work, the migrants begin packing their belongings in cars, vans, and trailers. They often leave with more than what they brought, so packing is complicated and involves careful planning. During the final days, they remove their children from school and make a final visit to medical personnel at the Migrant Center.

Once they are paid and their living quarters have been inspected and approved, they are ready to leave. Most make a quick visit to the bank to cash their checks and make a final trip into town for supplies in preparation for a trip that, for some, may exceed 50 hours.

Within days this vibrant neighborhood stands empty. An entire community has packed up and moved, leaving behind empty homes, buildings, and playgrounds. Soon winter will come, and the farm will lay dormant. Many of those who live around the farm or volunteer at the Migrant Center will wait for the return of their friends, their Latino neighbors.

A cold mid-October dawn will soon reveal the season's first frost. The growers have advanced weather-detecting equipment and are already in the fields preparing to protect the more fragile vegetables, including red lettuce, from the damaging conditions. The Zellers often run water lines throughout the night to create a watery mist that helps keep frost from damaging the crop. They make every effort to save their final harvest of the season. It is also a symbolic time for migrants working in the northern states because they know they will soon be done for the season and will need to move south to find work.

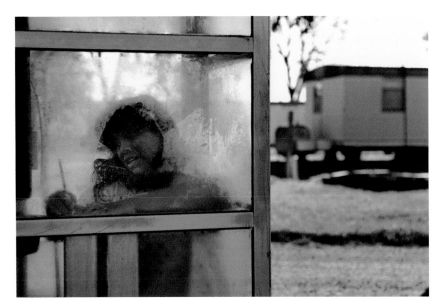

Beatrice Gutiérrez makes travel plans from a phone booth near her home. With her work done for the season, she is arranging to spend the winter months in Mexico.

Francisco Garza breaks from packing to share a song and stories about his life in Mexico. This was his first year in Hartville and the first time in 37 years he has been away from his wife.

Because of their transitory lifestyle, migrant workers' vehicles are one of their most important possessions. While one worker packs his daughter's bike for the long drive home to Texas, another helps load his and fellow workers' trucks and cars onto a rented tractor-trailer.

During their last days, the families start packing up and leaving. Each night another house or trailer goes dark. One camp and then another closes down, until one night you're driving down Duquette and the whole street is dark and gloomy.

MARÍA CONSUELO LÓPEZ

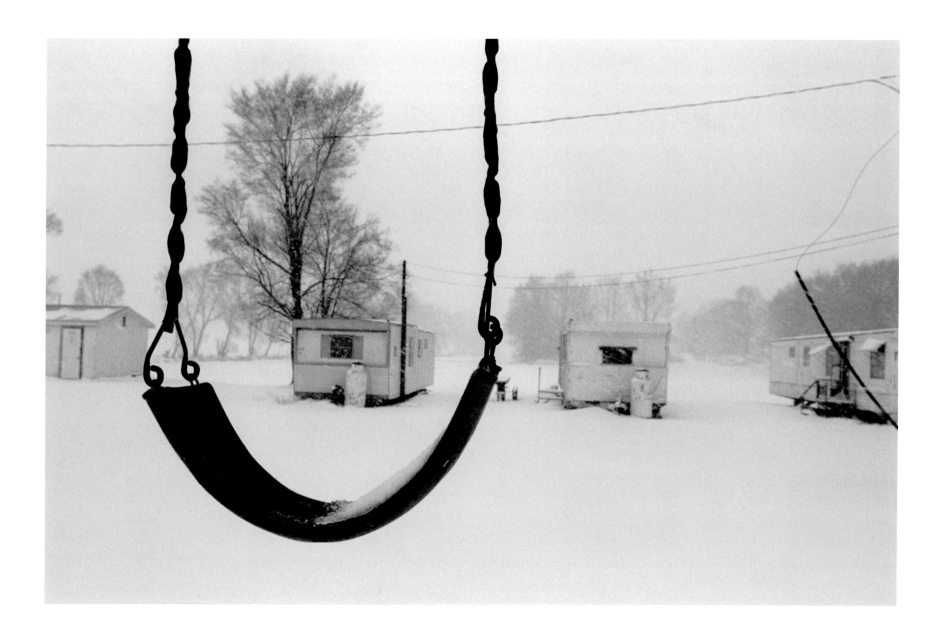

Voices

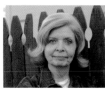
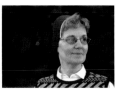
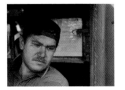
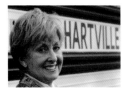
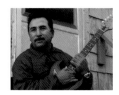
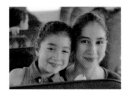
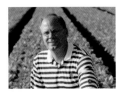
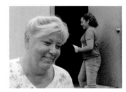

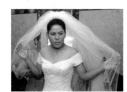
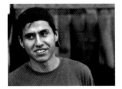

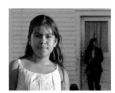
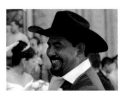
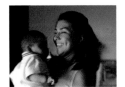
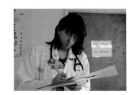

Acknowledgments

We are very grateful to the following people who have taken an active interest in our project and offered tremendous support: Carol A. Cartwright, president, and Paul Gaston, provost, Kent State University; K. W. Zellers and Son, Inc.; Ken, Jeffrey, David, and Rick Zellers; Teresa Brooks, president of the Hartville Migrant Council; Heather and Jeffrey Fisher; Brian R. Corbin, executive director of the Catholic Campaign for Human Development of the Diocese of Youngstown; Robert Coles; Terry Lee; Roberta Rosenberg; Susan dePasquale; Mario Morelos; Polly Wise; and Bee Moorhead.

We have been very fortunate to receive crucial financial support from several businesses and individuals in the Stark County community. We are sincerely grateful for the generosity of Fishers Foods, Jeffrey Fisher, president; Aultman Health Foundation, Edward J. Roth III, president and CEO; Key Foundation, Thomas E. Tulodzieski, president, Key Bank–Eastern Ohio District; and Pat and Jerry Moore.

We also wish to thank the Ohio Arts Council for an "Artists and Communities" grant, which helped to fund this project.

We are also very grateful for the support of our partner museums, the Canton Museum of Art, Canton, Ohio, and the Butler Institute of American Art, Youngstown, Ohio.

Working with the Kent State University Press has been a very rewarding experience. In particular, we wish to thank our editor, Joanna Hildebrand Craig, for her unstinting enthusiasm, her unerring judgment, and her keen eye; the director of the Press, Will Underwood, for his commitment and dedication; and the designer, Christine Brooks, for the elegance of the book.

For their professional expertise and advice, we wish to thank Campus Camera and Exchange and Kent State's University Communications and Marketing, Wick Poetry Center, and College of Nursing.

There have been many other individuals who have offered us support and advice throughout the project. We would like to thank: Jerry Miller, Billy Ohman, Penny and Steve Griffin, Teresa Wurst M.D., Lora Wyss, Scott Fleming, Penny Cukr, Jeff Stewart, Sister Teresa Ann Wolf, Sandra and Pete Procaccio, Jared Zurcher, Charles and Jan Brill, Bill Beardall, Debbie Diener, Candy and Bill Wallace, David Lockshin, Davina Gosnell, Connie Stopper, Maggie Anderson, Theresa Minick, Ken and Hyla Cushner, Jerry M. Lewis, Shannon Szwarc, Teresa Hernandez, Jeff Glidden, Bob Christy, Scott Galvin, Betty Hilgert, Lee Marriner, Alan Goldsmith, Jeff Miller, Ron Kuntz, Greg Ruffing, Bridget Commisso, Donna DeBlasio, Rod Flauhaus, Ralph Sinistro, David Strauss, Michal Urrutia, Joan and Vincent Stallone, Gayle and Jon Turk, and Glenn Harwood.

We would like to acknowledge the support of employees of K. W. Zellers and Son, Inc.; the students and volunteers at the Hartville Migrant Center; and the Hartville Migrant Ministry Council.

In loving memory of those who passed away during the production of this book: Penny Cukr, Charles Brill, and Francisco Mata.

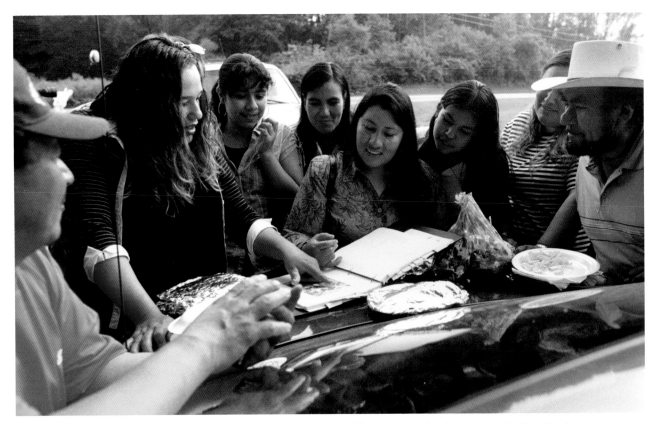

Workers and their families view and give feedback on the photos of their community that appear in *Growing Season*.

For more than 40 years, the Hartville Migrant Center has existed solely on the generosity of others.
If you would like to contribute to the Hartville Migrant Center, send your charitable donation to:

The Hartville Migrant Center

PO Box 682

3980 Swamp Street

Hartville OH 44632

www.hartvillemigrantministries.org

(tel.) 330-877-2983

For lesson plans and more information on the book, visit www.growingseason.net.